Victoria and Albert Museum

DAUMIER

Eyewitness of an epoch

J. R. KIST

BARRON'S

All inquiries should be addressed to:
Barron's Educational Series, Inc.
113 Crossways Park Drive
Woodbury, N.Y. 11797

Library of Congress Catalog Card No. 79-53648

International Standard Book No. 0-8120-2122-3

PRINTED IN THE UNITED STATES OF AMERICA

Contents

Daumier and his times

Honoré Daumier was a French painter and graphic artist with a deep concern for the political and social developments of his times. Between 1832 and 1872 he drew, on average, two illustrations a week for Paris newspapers. Under Louis-Philippe, the Second Republic, Napoleon III and the Third Republic there were a great many suitable subjects (see Chronological background), although for thirty of these forty years the artist's freedom of choice was restricted by an official censorship. Daumier's varied oeuvre includes 4,000 lithographs for newspapers, and 1,000 wood engravings for newspapers and books. It is estimated that he produced 300 paintings and 1,000 drawings, besides modelling figures in clay. It did not all come easily to him: he had trouble with the technique of painting, the art he preferred, and he disliked making wood engravings because he had to leave the actual work of engraving to others. However, he was in his element when working on lithographic stones, and it is with his lithographic work that this book is concerned.

'What is there left to say about this famous caricaturist that has not already been told', wrote *Le Courier de Paris* two weeks after Daumier's death. He enjoyed rowing on the Seine and smoking his pipe in silence. The sole dramatic event of his life was his term of imprisonment and, much to his own amazement, it was this that made him famous. The article finally quoted Daumier's own words, 'I haven't a particle of ambition, and by nature I'm lazy. I care more about my pipe than about fame and honours.'

For biographers, it is extremely trying that there is scarcely a sensible word of his to quote. He was anything but romantic, and in fact he was very like the kind of bourgeois he so often poked

fun at, just an ordinary man with a 'Newgate fringe', a turned-up nose, and a rather thickset figure (his height, 5′ 7″, was recorded when he went to prison) (Pl. 1). He was very shy, particularly in the presence of strangers, spoke with a strong Provençal accent, and had difficulty in expressing himself, although this was camouflaged by his pipe. He only came out of his shell when drinking with friends, and, since he was modest, kindly and honest, he had a great many of them. Only his eyes were remarkable, acutely observant, and retentive of the impressions he would later record on lithographic stones. He rarely made preliminary sketches. His utterly human figures (see the man on the right in Pl. 2) passed through the filter of his memory. When he lived on the Ile Saint-Louis, the small, peaceful island in the Seine, he was 'Captain' of a rowing-boat, 'The Barbel', which formed part of the 'Bercy Flotilla'. On warm summer evenings the fleet of illuminated boats set out for this village, with a band in the leading craft. Bercy was only a few miles away and well-provided with hostelries and arbours where the tired oarsmen could disembark. Because of its enormous wine depot, wine was duty-free, a privilege retained until 1870, when Bercy had long been swallowed up by Paris. Daumier liked nothing better than drifting downstream in pleasant company (Pl. 3). The careful observer will also notice a female, usually seated at the helm.

He felt suspicious when people praised him and was embarrassed when the poet and art critic Baudelaire called him one of the most important of modern artists. In this much-quoted article, which was written in 1851, Baudelaire referred only to prints, not to paintings, and since he was relying on his memory, he was not sure whether some of the prints were by Daumier or by his colleagues. In 1851 Daumier also had a visit from the historian Michelet, who fell on his knees before him. Once the shock of this had passed, the two gentlemen got on very well together. Michelet's words, 'Through you, the people will be able to speak to the people', hold more than a grain of truth, for Daumier was at home with simple folk and felt closely akin to them. He drew situations that were clear to all, and set them against familiar backgrounds. If the newspaper reader failed to recognise himself in the caricatures, at least he recognised his

neighbour. A young colleague, the caricaturist Forain, said at Daumier's funeral, 'He was quite different from us, he was generous.' I believe it is possible to learn about Daumier's character and habits, as well as about his likes and dislikes, from his lithographs. Extreme caution, however, is required when coming to any conclusion, since he was not responsible for the subject of many of his prints, and the captions were written by text-writers. On the other hand, he usually supplied an explanation along with the stone. Themes such as the theatre, exhibitions, railways, tourism, photography (Pl. 60), fashion, swimming-baths, oarsmen and bluestockings were also drawn by less talented colleagues during the same period. He produced a surprising number of very mild caricatures such as a father sitting up in bed while his small son wishes him a happy birthday, and 'When you are twenty' (Pls. 4 and 5). And is there not something touching about the overjoyed couple who have survived the comet? (Pl. 59). His fiercest attacks were aimed at the monarchy and clericalism and all they entailed (Pls. 10, 11, 12, 13, 46), whilst his affections went out to the underdog, the Republic and the French people (Pls. 7, 14, 15). He was unable to work up much enthusiasm for women's movements (Pl. 6), or for the veneration of classical art (Pls. 8, 9). This may have had something to do with his own youth and his father, who wrote classical tragedies while letting his family all but die of starvation.

Daumier himself attached little value to the text. 'If my drawing does not convey anything to you, it must be bad, and no caption can remedy that. If the drawing is good, you will be able to understand it without any further commentary.' This may well have been true in the case of his contemporaries, but it is less simple nowadays. No systematic attempt has ever been made to explain all the scenes. The print of a horse walking into the house of a gentleman wearing a nightcap (Pl. 71) has a background of truth. It happened in the rue de l'Etoile. A horse walked into a house and, to the alarm of its occupants, up the stairs to the fifth floor. It then descended, sliding down on its hind quarters. Daumier found it an interesting subject. In the nineteenth century, horses were frequently used as models, and the animal painter Rosa Bonheur even had a stable containing a horse, sheep and goats next to her studio. Other artists were

3

unable to afford such luxuries and had to make do with hiring their horses. This gave them a splendid opportunity to tie the model's bridle to a neighbour's front door bell and then beat a hasty retreat. The horse shook its head, the bell rang, and the occupant of the house was astounded to find a horse standing outside his front door.

Daumier drew a great many different kinds of people and rarely repeated himself (Pls. 16-36). There is hardly an attitude, gesture, mood or human relationship that he did not illustrate, constantly simplifying the means he employed. For his allegorical figures he frequently used two types, a well-built young woman representing the ideal (Peace, the freedom of the press, the Republic, etc.) and, in contrast, a bedizened old hag symbolising the pernicious ills of diplomacy (Pls. 37, 38, 39 and 94).

The actual printing was quite a complicated process. After the stone had been collected from Daumier, it was given a number and a few proofs were made (Pl. 64). Then the frame and caption were added. If the printer and censor approved it (Pl. 39), the first impressions were made on white paper for sale, and then the stone was used for the newspaper. If the print was successful, further impressions on white paper followed. In 1864, besides working for *Le Charivari*, Daumier also produced lithographs for *Le Journal Amusant*, which used a different method. The lithograph was transferred to a zinc plate and printed along with the newspaper. In 1870 *Le Charivari* switched to the same system. Daumier worked extremely hard in his early years, and often laboured for days over one stone. Later on his speed increased, and he was then able to draw eight lithographs in one evening by placing the stones on a round table and walking round them. The illustrations in this book are mainly prints from *Le Charivari*.

Honoré Daumier was born at Marseilles on 26 February 1808. His father was a frame-maker with literary ambitions, but his mother signed her marriage certificate with a cross. In 1816 the family settled in Paris, where Daumier's father gained some success with a tragedy and a volume of verse, but was nevertheless unable to support a wife, a son and two daughters. In fact, it was the other way round. At the age of 12, Daumier Junior started work as a bailiff's assistant (Pl. 18), and then moved on to a bookshop. Finally, the painter and archaeologist Lenoir took

him under his protection. Lenoir was a most remarkable man who, at the time of the Revolution, had rescued sculptures, including Michelangelo's 'Slaves', from churches and palaces. He introduced Daumier to the lithographer and portrait artist Zéphirin Belliard, who gave him a thorough grounding in technique. In his fourteenth year Daumier made a lithograph to earn some extra money, but his career as a lithographer began with the rise of Louis-Philippe.

The July Revolution of 1830 overthrew Charles X, the last of the Bourbon kings, and brought Louis-Philippe of the House of Orleans to the throne. The Government's July-Ordinances dissolving the Chamber, limiting the franchise and tightening up the censorship met with fierce resistance from the liberal press. On 26 July the first street incident occurred in the Place du Carousel when typographers and students from the Ecole Polytechnique staged a demonstration. The typographers were chased up the street by the police, who then occupied the protesting newspapers' printing works. In the next few days, 'The Three Days of Glory', it was primarily the students who were active in erecting barricades from street pavings, furniture, wine casks and all kinds of vehicles. In the meantime, the moderate opponents of Charles X's conservative rule took fright. Supporting the cause of the 56-year-old Louis-Philippe seemed to them the only way to avoid revolution and chaos, and so, at 2 o'clock in the afternoon of 31 July, a colourful, if somewhat ludicrous, procession emerged from Louis-Philippe's home, the Palais Royal, on its way to the Town Hall. It was led by one of the heroes of the barricades bearing a tricolor; then came Louis-Philippe dressed as a general and riding a grey. He was followed by the well-known writer and politician Benjamin Constant in a litter, a drunken drummer, and a group of Deputies shouting 'Long live the Duke of Orleans'. At the Town Hall another hero of Liberty, Lafayette, raised some objections, but Louis-Philippe dragged him on to the balcony with him and waved the new tricolor above the heads of the cheering crowds. The day was won, and the good citizens of Paris could stop worrying.

Today, Louis-Philippe is judged with far less severity than he was in the nineteenth century. Apart from being a hard worker and a model father, he was a highly capable statesman, convinced

5

that he knew better than his Ministers, which he frequently did. With his histrionic gestures, rotund figure, shabby top hat and inevitable umbrella, he was scarcely regal in appearance; the Emperor Napoleon III was to present a better figure. Heinrich Heine, for many years the Paris correspondent of the Augsburg newspaper, tells how, shortly after his accession, the King was shown to foreigners for 5 francs. A group of 'claqueurs' (hired spectators at the theatre) started to shout 'hurrah' in front of the Palace, and the Citizen-King promptly appeared at the window, bowed and disappeared. But if the claqueurs were given 20 francs and started singing the Marseillaise, he came out on to the balcony, placed his hand on his heart and joined in the singing, beating time with his foot. And although this tale is almost too good to be true, it is highly characteristic of the King and his efforts to appear democratic. It was soon apparent that the new King had stirred up a hornet's nest. It was far from easy to steer a middle course and stand up to the fierce opposition from the Legitimists (supporters of Charles X) and Republicans. He succeeded in controlling the opposition in Parliament, but the opposition newspapers with their increasing influence on public opinion were far more dangerous. Reintroducing censorship was out of the question for the time being, and so the Government had to confine itself to charges of insulting behaviour towards the King and agitating against the Government. The first systematic attacks came from the Legitimists, since they were better organised, and had more money than the Republicans who launched their campaign in 1831. Seizure of property, steep fines and imprisonment failed to produce the required effect. In more than half the court cases, the Jury returned a verdict of not guilty, and the accused and their Counsel availed themselves of every opportunity to voice their political opinions. One of the masters of this exciting art of political fencing was the artist and journalist Charles Philipon (1800-1862), a convinced Republican. At the time of the July Revolution, he had already gained some experience as a draughtsman for, and the editor of the political periodical *La Silhouette* (1829-1830). In 1829, without any capital, he and his brother-in-law Aubert set up a print-shop and publishing company in the Galérie Véro-Dodat. 'Chez Aubert' benefited from the spectacular development of lithography: vast

sales of prints and the publication of newspapers and booklets finally made the impecunious Philipon a rich man. *La Caricature* —first published on 4 November 1830—became the prototype of the satirical weekly. It consisted of two pages of text and two carefully printed lithographs on white paper. Its best-known artists were Grandville, Philipon's right-hand man, Gavarni, Traviès, Decamps, Raffet, Monnier and Philipon himself, the wittiest, but least talented draughtsman of them all. The same team collaborated on the daily paper *Le Charivari*, which made its first appearance on 1 December 1832 and consisted of three pages of text and one lithograph in each issue. Philipon had a highly stimulating effect on his associates, and possessed other qualities which would not have come amiss in a modern public relations man. He liked to be surrounded by young talent that he could mould, and he wanted young readers to promulgate his ideas. Daumier, now 23 years old, had worked with him on *La Silhouette*, and shared his editor's convictions. He had also been producing loose prints for the Aubert publishing company, and now joined the team of *La Caricature*. Daumier's wood engraving of 'Le Charivari's Orchestra' provides an amusing illustration of this collaboration. In the centre, Philipon beats the drum, to the left is his brother-in-law Aubert holding a sheet of music; on the right stand young Daumier with a tambourine and Traviès with a bassoon, while in the bottom right-hand corner Grandville is playing the flute. In this rousing company it did not take long for Daumier to develop from a somewhat undistinguished draughtsman into a great artist. Philipon's powerful influence on the hesitant Daumier remained in evidence until 1842, when he left *Le Charivari*. Daumier assimilated many of the ideas emanating from Philipon's fertile imagination, and cast them in his own particular mould. Strangely enough, he always had difficulty with political themes. The last Director of *Le*

Charivari for whom he worked, said he gave Daumier as much latitude as he could, but political prints were best discussed beforehand.

Philipon was obviously searching for a central theme to unite his team in the campaign against the King, but his success in finding one exceeded all expectations. The King's head and body resembled a pear, and, since 'poire' also means dimwit, this simple, easily recognisable shape was ideally suited to his purpose. At one trial, he entertained the members of the jury by making four drawings in which the King's head gradually changed into a pear. It was, after all, not his fault that the King so sadly resembled one! The invention caught on (see Pl. 44) and was taken over by other satirical papers. Even the Parisian street urchins starting chalking 'the Pear' on walls.

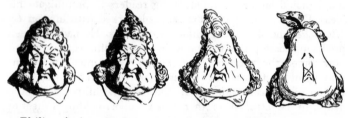

Philipon's imprisonment was bound to follow, and on 13 January 1832 he was locked up in the political prison Ste Pélagie, where rich Legitimists and poor Republicans formed two vociferous groups. Within its dank walls there was a considerable amount of freedom. Philipon was able to continue coaching his team, and managed to have himself transferred to a sanatorium with a large garden in the rue Chaillot. His promising pupil Daumier followed in his footsteps in the same year. A separate print of Louis-Philippe—as the glutton Gargantua sitting on a commode—attracted the authorities' attention, and on 23 February, two weeks after the publication of his first print in *La Caricature*, Daumier, the publisher Aubert, and the printer Delaporte were condemned to six months imprisonment and a fine of 500 francs. The sentence was suspended for six months to give the offender a chance to mend his ways, and it was during this period that Daumier was given a commission which greatly influenced his further development. Philipon sent him to the

Press Gallery of the Chamber to prepare models of Ministers and Government supporters. The actual work was carried out at a studio, presumably belonging to one of his friends. These small caricature busts, thirty-six of which still exist, served as preliminary studies for his drawings, but were also used as models by his colleagues. In fact, a great deal of borrowing went on within the group. Philipon kept the models, which were made of unfired clay and painted by Daumier in bright colours. Over the years they shrank, cracked, partly crumbled and disintegrated; they were restored many times and finally cast in bronze in the years following 1929. Nevertheless, even the bronze casts are most impressive (Pls. 16, 40). The graphic work which followed was the first to display a powerful character of its own. The lithographed busts, emblazoned with heraldic devices designed by Philipon (Pl. 41) were followed first of all by single, standing figures (Pl. 42), and then by groups, culminating in 'The Legislative Belly' (Pl. 43), where the faint curve of the benches is repeated in the abdominal folds of Ministers and Deputies. This work is a masterpiece.

Daumier's term of imprisonment from 27 August 1832 until 27 January 1833 was a turning point in his life. Daumier was the sole political artist to be imprisoned. At Ste Pélagie, where pears adorned the cell walls, the creator of Louis-Philippe on a commode was received with open arms. During his imprisonment he was forbidden the use of lithographic stones, and so he made portraits and a series of drawings which a colleague lithographed. He met famous pressmen, heroes of the resistance, and, a few days later, Philipon himself, who had again been immured in Ste Pélagie. Prior to this he had made sure that Daumier's parents received support. (Daumier earned 40 or 50 francs for a lithograph and 20 francs for a wood engraving, and this was the main source of income for his entire family.) The final months of his punishment were spent with Philipon at the sanatorium in the rue Chaillot.

In 1831, after the first convictions, Philipon published a list of subscribers to a fund for financing the increasing fines and legal costs and so continuing the struggle. His idea of involving his readers in his campaign assumed an attractive form when 'l'Association mensuelle pour la liberté de la presse' was founded

on 30 August 1832. In return for a 'share' of one franc per month, subscribers received a premium print by way of a supplement to *La Caricature*. Philipon addressed himself to the young in particular. '*La Caricature*, produced by young people, addresses itself to young people and appeals to them to aid a Society which seeks to defend freedom of thought. We must not lack the help of people of our own generation. We are relying on you.' In 1834 Daumier was responsible for five of these large, carefully detailed prints. Four of them belong to his best work of this period, i.e. 'The Legislative Belly', 'The Typographer' (Pl. 17), 'The Funeral of Lafayette', and, finally, 'Rue Transnonain, le 15 avril 1834' (Pl. 46), which was not published until 2 October. What had happened in the rue Transnonain on 14 April 1834? A workers' revolt at Lyons caused by a reduction in wages, spread to Paris, and heavy fighting broke out in the narrow streets between the Halles and the Town Hall. A police report on the events at no. 12 rue Transnonain has been unearthed. 'A certain Lebrun lived in this house. All night long he had shot at soldiers through an open window. After he had killed an officer, the soldiers entered the house and massacred eight men, a woman and a child, a fatal error.' A wave of indignation swept through France. Five months later people were crowding round the window of the Galérie Véro-Dodat to look at the print that was to make the artist famous at a single stroke. He had illustrated the moment when the soldiers had left the house, and their bloody footprints were still visible. The murdered family lie sprawled in front of a disordered bed; a child with his skull split open is just visible beneath the man in a nightshirt in the foreground. There is not much of a caption to this print, and it was hardly necessary to add one. It was not the sharp-witted Philipon, but the rebellious Daumier who was speaking here. The event took place in an environment similar to his own, and this was how the soldiers might have behaved in his parents' bedroom. It was the first time he had succeeded in freeing himself from his surroundings and in expressing his abhorrence of violence simply yet monumentally. The name of the street was changed long ago, but rue Transnonain has remained legendary.

In the accompanying text in *La Caricature*, Philipon voiced his thoughts on a bloody page in the history of the modern world.

The Government decided to prosecute the instigators of this 'April Revolt' in the Upper House (Chambre des Pairs), and, of the 1,500 persons arrested, 121 were charged. This resulted in a gigantic trial which lasted for nine months and involved 800 witnesses, stacks of paper, mass demonstrations and displays of military force (Pls. 47, 48). After a few months interest waned, and a general amnesty followed. In the meantime the freedom of the press was declining. It was generally expected that there would be an attempt on the King's life on the anniversary of the July Revolution. The opposition press made fun of it all. On 26 July 1835, *Le Charivari* wrote, 'Yesterday the King and his Illustrious Family returned to Paris without having been assassinated in some way or other.' On 28 July an attempt was made on his life with a kind of machine gun. It was plotted with as much forethought as the assassination of President Kennedy, and eighteen people were killed. The King was only grazed, and the procession continued as planned. In the evening, when both Chambers arrived to congratulate him on his escape from death, Louis-Philippe burst into tears. Censorship of the press was re-imposed on 9 September, and in the final issue of *La Caricature* of 27 August 1835 (Pl. 49), the heroes of the July Revolution wondered why they had sacrificed their lives. A brilliant period in the history of the political print had been concluded. *La Caricature* ended up with a large deficit. *Le Charivari* continued the struggle, but now it was directed against bourgeois society.

In 1836, Philipon had another brilliant idea. The picturesque comedy *Robert Macaire*, a social satire, had been enjoying a long run in the Paris theatre. Philipon used this theme for a series of prints—121 in all—in which, aided by his henchman Bertrand, Macaire conducts his evil practices as a promotor of shady enterprises, a banker, manufacturer, notary public, marriage broker, hypnotist, lawyer, etc. The illustrations show a vast variety of confidence tricksters and quacks such as are to be found in every profession in a society interested mainly in money. The names of Daumier and Philipon appear beneath each print, and the 78th in this series (Pl. 50), in which the Prince of Rogues compliments the artist, provides an amusing illustration to this partnership. It is neither Daumier nor Philipon who is sitting by the lithographic stone, but a combination of the two. Daumier with his

Newgate fringe has been given Philipon's long nose. The Macaire series was a huge success, and separate albums containing the prints were issued in large numbers. *Le Charivari's* circulation increased, as did Daumier's fame, and towards 1840 he had, in the eyes of the public, become one of the best caricaturists of the age. The prohibition on making political prints resulted in his starting to draw the people around him. The daily life of the Parisian and the perils of matrimony provided an abundance of material for his prints; his vision widened and his draughtmanship developed with greater freedom.

In 1845 he moved to the Ile St Louis, which still had the appearance of a seventeenth century provincial town. It harboured a flourishing colony of progressive artists and scholars. Daumier spent the best years of his life there and made some lasting friendships. He lived on the fourth floor of no. 9 quai d'Anjou; the attic, with views of both banks of the Seine, was furnished as a studio, and there he worked amidst indescribable chaos, humming popular tunes, receiving his friends and smoking his pipe. There is a photograph of Daumier standing in the gutter, surveying the neighbourhood; there was always something to be seen on the Seine or along its banks that he might be able to incorporate in his prints and canvases. In 1846 he married the seamstress Marie-Alexandrine d'Assy, commonly known as Didine or Négresse, who was fourteen years his junior; it turned out to be an outstandingly happy match. There is a story from this period that Charlie Chaplin might have used as a scenario. One evening Daumier met a drunk who was unable to open his front door. The arrangement was that his wife would throw down the key when he whistled, and this he could no longer manage to do. Daumier whistled for him, and a window was flung open on the sixth floor. A bucket of water was emptied over him, the key clattered on to the cobble stones, the man disappeared indoors and Daumier was left to continue on his way.

In the meantime, Louis-Philippe's position was rapidly deteriorating. The worst blow to befall him was when the Crown Prince, the hope of France, met with a fatal accident in 1842. His successor was four years old, and the 68-year-old King, who had survived eight attempts on his life, no longer had the strength to take action against the mounting opposition. His peace policy

was not appreciated by the broad masses of the population, and he was not interested in social reform. His tendency to avoid facing up to difficulties, and his efforts to make himself popular, ultimately became fatal to him. Even the National Guard, whose members were drawn from the petty bourgeoisie, deserted him. On 24 February 1848, when the barricades had already gone up throughout Paris, he wearily mounted his grey for the last time to inspect the National Guard, but when it became menacing he returned to his palace, sank dully into his chair, and signed his abdication to avoid causing any further bloodshed. He shaved off his side-burns and fled to England; the palace was plundered (Pl. 52). Daumier's dream, the Republic, was finally to come true (Pl. 14). People started planting a Tree of Liberty in every square. It was a time for progressive ideas and illusions. The right to work, nationalisation of industry, universal suffrage, freedom of the press, divorce (Pl. 53), all were scrutinised and discussed. At the Paris Peace Conference Victor Hugo spoke of the 'United States of Europe', and Pastor Cocquerel of general disarmament (Pl. 54). Artists too wanted a change. The jury for the great annual exhibition of paintings, the 'Salon', was sacked, and the following year for the first time it was made up of artists. Daumier hoped to be able to devote himself entirely to painting.

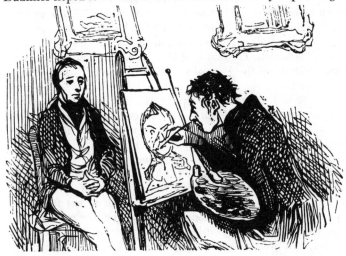

He was given an opportunity to carry out two important state commissions, but despite the encouragement of his Republican friends, who were briefly in a position to dictate their wishes, he never progressed beyond preliminary studies. His canvases in the Salons of 1849 and 1850 were not very successful, and he himself was dissatisfied with them.

The Second Republic was not to last, although in 1848 the Republicans were not greatly worried about the drowsy, taciturn man whose fortunes were to rise like a comet. Prince Louis-Napoleon seemed more like a character from the world of comic opera than a serious Pretender to the throne. In 1836 he made a vain attempt to win over the garrison of Strasbourg, but was taken into custody and—since he had not a sou in his pocket—sent to New York with 15,000 francs. In 1840 his second attempt to gain power was partly financed by his mistress, Miss Howard, a lady of easy virtue with magnificent red hair and a wealthy clientèle. Accompanied by 50 retainers, he left England in a paddle-steamer, the *Edinburgh Castle*, laden with horses and carts, rifles from Birmingham, second-hand uniforms, new evening clothes and proclamations. Before leaving Gravesend, he just had time to buy a tame eagle, symbol of the Empire. The Garde Nationale arrested the entire company two hours after it had landed on the beach at Boulogne. This time the Senate sentenced him to life imprisonment in Fort Ham, but in 1846 he managed to escape as 'Bricklayer Badinguet', with a plank on his shoulder and a clay pipe in his mouth. The Count of Monte Cristo, whose adventures were enthralling the Parisians at the time, could hardly have done better.

In 1848 he first became a Deputy, and then a candidate in the presidential elections. Against all expectations he was elected (Pl. 55), the principal reasons for his success being fear of the 'Reds', and nationalistic sentiment which had been disappointed during the reign of the 'Pear'. 'Badinguet' was even popular with many of the workers. He settled in the Elysée Palace, and Miss Howard moved into an adjoining house. During his presidency which, according to the Constitution, was not to last for more than four years, both his good and his bad qualities came to the fore. He still spoke very little, listened patiently, never lost his temper, and brooded over the schemes which, unhampered by

14

any scruples, he proceeded to have carried out. Loyalty did not deter him from unexpectedly sending his most faithful supporters a letter saying he no longer required their services. On the other hand, it must be said that, as a result of his initiatives, France prospered as never before, and that, socially, he was far in advance of his environment and his times. The coup of 2 December 1851 was prepared down to the smallest details, Miss Howard contributing towards the cost. After a reception at the Elysée Palace the conspirators met to carry out the 'Rubicon' plan. A large number of Deputies were locked up, soldiers occupied strategic points and posters issued in the name of the French people proclaimed a state of siege, the extension of the presidency to ten years, and a plebiscite. There was scarcely any resistance. When a riotous crowd gathered, a few hundred on-lookers were shot dead. The coup had succeeded and, throughout France, Republicans were arrested and banished to Algiers. Everything now went smoothly. A large majority, opting for authority, patriotism and glory, approved the coup and the restoration of the Empire exactly one year later, on 2 December 1852. The Emperor married the Spanish Countess Eugénie de Montijo, and Miss Howard disappeared from Paris after the police had first ransacked her home to take possession of any compromising letters.

Le Charivari scarcely had a chance to point out the dangers of dictatorship to its readers, but Daumier invented the character 'Ratapoil' to express his abhorrence of the police state. Ratapoil was presented as the leader of the strong arm brigade who shouted 'Long live the Emperor' and indiscriminately beat up passers-by (Pls. 56, 57). In one of the prints Daumier himself was the victim. However, with the reintroduction of censorship, Ratapoil disappeared into the darkest corner of the house, and Daumier went on drawing everyday happenings. When his contract with *Le Charivari* was broken in 1860, he thought he would be able to live on the income from the sale of his oil paintings and watercolours, but this proved a fatal miscalculation. He ran into debt and had to give up his home on the Ile St Louis. A large part of his furniture was sold, and he went to live in Montmartre. However, his worst troubles were over when his contract was renewed in 1863 and the event celebrated at a

festive dinner-party. The break in his old routine had done him good. He was given greater freedom in the choice of his subjects and his prints for *Le Boulevard* (1862-1863) and subsequently for *Le Charivari* were of a better quality (Pl. 73). After 1863 sales of his paintings also improved. On the advice of his colleague Daubigny he rented a house at Valmondais on the Oise for 250 francs per annum. He spent the summer months there and travelled to and from Paris. Many of his finest railway illustrations date from the time of his journeys to Valmondais.

The Second Empire brought some extraordinary people to the fore. The learned M. Babinet gave popular lectures about the wonders of the universe, but was unable to dispel the fear of comets (Pls. 58, 59). The actor and playwright Henri Monnier, a former comrade of Daumier's from the time of *La Caricature*, introduced the average Parisian, Prudhomme, to the stage. M. Prudhomme was in favour of maintaining authority and also his own comforts. He believed in the advance of civilisation and was interested in the latest domestic contrivances such as the gas-ring and the sewing machine. The most striking personality was Nadar (Pl. 61), a balloonist, photographer, author and caricaturist, who was described from life in Jules Verne's *The Journey to the Moon*. He travelled across Europe with his famous balloon 'le Géant', gathering huge crowds of spectators wherever he went. The portrait photographs he made of his contemporaries, including Daumier, are highlights in the history of photography.

The greatest changes in France resulted from the development of the steam engine and the expansion of the railway network. On 26 August 1837 Louis Philippe's consort and her daughter Marie made the first train journey from Paris to St Germain. The Cabinet had advised against this dangerous excursion; two days later, however, it had already become extremely popular. Trains ran hourly, half-hourly on Sundays, and a third class ticket cost 75 centimes. On Sundays, thousands of Parisians went for walks in the woods, made boat trips on the Seine, or went dancing in the outdoor establishments, which could hardly cope with the crowds. There was money in railways, and the bankers Rothschild and Fould each financed a line to Versailles, one from the right banks of the Seine, and one from the left. Excursions to the Park at Versailles remained popular in spite of a railway disaster, when

more than 50 people were killed on the small Fould line. The guard had, as usual, locked the doors before the train's departure, and then the wooden carriages caught fire. The railways led to the development of tourism, and large hotels were built (Pls. 62-67). Economically, however, the transport of food, wood, steel, and particularly coal was of far greater importance. The main railway lines radiating from Paris were constructed between 1843 and 1855, and by then the time had come to hold the first World Exhibition in France.

The modernisation of Paris during the Second Empire was the most drastic ever undertaken in a capital city. In 1853 the Emperor appointed Haussmann Prefect of the Seine, and the latter submitted a memorandum outlining his plans, which included: (a) clearing space round historic and public buildings, palaces and churches, (b) promoting public health by operations such as slum clearance, (c) laying out wide boulevards which were healthier and better suited to troop movements in the event of civil disturbance, and (d) improving links with railway stations.

The new boulevards and great traffic arteries were the most spectacular of the works carried out, but the water supply and drainage systems (800 kms and 430 kms) were no less important. The covered markets (the belly of Paris) became a model for other countries. The most popular places were the Champs-Elysées, the Etoile, and the Bois de Boulogne, where elegantly dressed ladies were driven to and fro in their carriages. The crinoline was closely associated with the Second Empire (Pl. 83), and the wives of the new financial magnates, society ladies, world famous prostitutes and all grades in between tried to outshine each other in the splendour of their expensive clothes. The Empress Eugénie had herself and her brilliant ladies painted by Winterhalter in a group which itself had the shape of a crinoline. An 82-year-old Deputy spoke with youthful fervour about the disastrous effect of the crinoline on the petty bourgeoisie: women spent far too much money on clothes and so were led astray.

There were all kinds of objections to the Haussmann plan apart from the loss of beautiful houses which were replaced by uniform apartment blocks. In the old days, the cobbler lived in the basement, the gentleman on the bel-étage, and the dressmaker or artist on the top floor. Now the various classes were

17

separated, and the poorer people suffered, since they could not afford the high rents of the new apartments and were compelled to live a long way from their work. Compulsory purchase and the new building works encouraged speculation, corruption and other unsavoury practices, just as they had done when the railways were built. Compared with these, Robert Macaire's little tricks seemed quite innocuous. Daumier drew the demolition workers who arrived in large numbers from the provinces, the couple who suddenly felt the sunshine coming into their home (Pl. 68), the open air dancing establishments, and the large cafés along the boulevards (Pl. 73). It was a pity that, in spite of the rapid development of science and technology, the progress M. Prud-homme was always talking about could not manage to keep up the pace. To house the first World Exhibition, a new building was erected with an entrance in the Champs-Elysées and, along the Seine, a rectangular extension constructed of metal and glass for the display of locomotives and other steam engines. The changes taking place in Paris filled visitors from abroad and from the provinces with amazement (Pls. 69, 70). It gave the Emperor great satisfaction to conduct Queen Victoria round the exhibition and his city of Paris. The Queen was charmed by him and wrote to her uncle Leopold of Belgium, 'I am delighted, enchanted, amused and interested, and I think I never saw anything more beautiful and gay than Paris.' The power of France was increas-ing and the Emperor became, if briefly, the arbiter of Europe that de Gaulle would so much have liked to be.

In his lithographic work, Daumier showed a certain preference for three subjects which he drew again and again in the course of forty years of providing illustrations for newspapers: the people at the Palais de Justice, actors and their audiences, and painters and visitors to exhibitions. The quiet Daumier always felt attracted to eloquent, gesticulating people, and the Palace of Justice was one of the places where they were to be found. These prints are difficult to acquire, and some of them are to be found in the chambers of judges and barristers, who still recognize their colleagues in them (Pls. 75-78). In the years following 1852 interest in the theatre and cabaret increased among all sections of society. This was also true of Daumier. He no longer remained seated or standing in the gods, but went on to the stage as well as

back-stage and into the dressing-rooms of friendly actors (Pls. 22, 79-82). One remarkable print (Pl. 84) shows the 'Bearded Woman' (the well-known cabaret artiste Thérésa) standing next to Tragedy. Thérésa was one of the great attractions of Paris and drew deafening applause when, in a deep voice, she sang the song of a fairground woman who let people pull her beard for 10 centimes and was able to lift tremendous weights. The best-dressed woman in France, Princess von Metternich, wife of the Austrian Ambassador, gave excellent imitations of Thérésa, and so the 'Bearded Woman' was also sung by the Court at the Palace of Compiègne, where the Empress Eugénie might join in the refrain, 'C'est moi que je suis la femme à barbe'.

The second figure in this print was the tragic actress Cornélie of the Comédie Francaise. She was the first person to recite the tragedies of Racine and Corneille at a cabaret. Daumier was most familiar with the artist's way of life (Pls. 85, 87). From 1850 onwards he was associated with the Barbizon painters, and Daubigny was one of his best friends. Paris in the nineteenth century may well have been the pulsating centre of modern painting, but many artists led a poverty-stricken existence. There was really only one opportunity for them to exhibit new work and gain the recognition they needed to support themselves. This was at the 'Salon', named after the large square room in the Louvre, the Salon Carré. Canvases were hung in five tiers, but the room soon became too small and the Salon began taking up more space in the Museum each year. The problem was not solved until two years after the 1855 World Exhibition, when it became possible to use its premises for the annual 'Salon'. The building was quite pleasant and comfortable inside, and provided ample space, plenty of plants and flowers, a restaurant, and comfortable seats for the visitors (Pl. 86). The exhibition lasted for three and a half months. On Sundays admission was free, and sometimes there were 50,000 visitors in a day. People were attracted there by a colourful display of melodrama, military scenes and naked women. There was an indescribable crush in front of some of the paintings, and pickpockets made good use of this. For Paris the Salon was a great annual event, and newspapers devoted a great deal of attention to it for months. Many artists regarded rejection as a disgrace, and throughout the nine-

teenth century they protested vigorously at the composition of the jury. Either its members knew nothing at all about art, or else they were merely part of the old-boy network. In 1863, when the jury had again rejected a large number of entries, Napoleon III, who prided himself on his open mind, came to see for himself and ordered the rejected works to be exhibited in the same building a fortnight later. Most of the contributors refused, but more than 600 canvases were hung, and one of them attracted indignant crowds. It was an 'immoral' work, showing two clothed artists sitting out of doors with a naked model—Manet's *Le déjeuner sur l'herbe*.

The Government became more liberal-minded after 1860, although the freedom of the press was not restored until 1868, when a great many new papers appeared. By then, Napoleon's best years were past, his foreign policy was breaking down, and a kidney complaint was undermining his will-power. His great political opponent, Bismarck, proved too clever for him and the Empress Eugénie, who acted as Regent during the Emperor's absence or sickness, interfered too much in affairs of state. France was heading for catastrophe, a development that can be followed clearly in Daumier's almost classic prints. By the beginning of 1870 the wretched French Government, supported by the blinkered majority of the people, had reached the edge of the abyss (Pl. 90), and, less than a year later, France was plunged into mourning (Pl. 91).

Fate marched swiftly on. War with Germany broke out on 19 July 1870. Napoleon, racked with intolerable pain, was unable to play an active part in the command of the army. Surrounded by German troops in the small town of Sedan, he decided against making an heroic gesture and surrendered. On 4 September the Third Republic was proclaimed. The enemy had by then advanced close to Paris, and the siege, which was to last for over four months, began on 19 September. During the siege and the Commune, the revolutionary socialist Government, Daumier was living in Paris. The severe winter of 1870-71 brought famine and fuel shortages to its two million inhabitants. There was only one important means of communication left, the balloon. Nadar immediately formed a team of balloonists, and received help from sailors. The first balloon, 'Neptune', left Paris on 23 September

and came down safely behind the German lines. Two days later three carrier pigeons went with it and returned within six hours. A postal link—later on micro-photographs were included—had been established. On 12 November the balloon 'Daguerre' fell into the hands of the Germans. They took the opportunity to return a false message by pigeon post, but signed it with the name of a civil servant from Tours who happened to be in Paris, a blunder which vastly amused the French (Pl. 92).

It was only natural for the Emperor to be held responsible for the disastrous outcome of the war, although the French people were no less guilty (Pl. 93). France fortunately managed to make a rapid recovery, but first, after the signing of the Peace Treaty on 10 May 1871, came the worst carnage ever experienced in Paris.

With the suppression of the Commune, reactionary elements regained control. More than 20,000 of its supporters were executed by firing-squad, and later on 21,000 more were convicted by military tribunals.

In 1872 an eye disease compelled Daumier to give up working for *Le Charivari*. Some twenty more of his prints were still to appear in various papers, and after an operation in 1873 he started painting again. Until recently, all biographies of Daumier gave a depressing account of his last years. There was a particularly persistent story that his perceptive colleague Corot gave him the small house at Valmondois because the destitute and semiblind artist could no longer afford to pay the rent, but the facts are different. It was only in his youth that he experienced extreme poverty. As soon as he became associated with a newspaper he had an adequate income, but being very hospitable and a bad manager, he was always worried about money. In this respect the situation was no worse in his last years. The sale of his paintings and drawings more than compensated for the loss of a regular income from *Le Charivari*. Daumier's state pension of 1,200 francs per annum (a labourer earned 1,300-1,500 francs) was increased to 2,400 francs in 1878. When the lease of the house at Valmondois expired in 1874, he bought it—with or without Corot's help—for 3,500 francs. He kept on his Paris apartment until 1878. In the same year one of his friends organised an exhibition at the Durand-Ruel art gallery, and this

was very well reviewed. Of the 94 paintings on view, 17 were from Daumier's own studio, and the remainder came from 37 different collectors. Watercolours, prints and clay figures were also displayed. The first catalogue of Daumier's graphic work, including his only etching (Pl. 96) was published by the well-known author and art critic Champfleury. He was surrounded by friends and admirers until his death on 11 February 1879.

The qualities that detach Daumier's prints from history and give them a timeless character are his acute powers of observation, his humanity, and his simplicity. Sometimes, when the political situation has not changed very much over the past hundred years, the prints are surprisingly topical. However, Daumier's sense of the topical went beyond that. He described the world around us, and an instant recognition of human re-actions and relationships makes us feel he has drawn something from our own times, for example the married couple indignantly watching the young people dancing the can-can (Pl. 72). The powerful effect of his prints can be clearly felt in the boxing contest between England and Ireland (Pl. 95). The entire scene appears to have been rapidly and cogently recorded on a stone, and anything that might distract the attention has been omitted. The opponents face each other like sculptured figures, and it is immediately apparent that Daumier's sympathies were on the side of the underdog. The emaciated figure of Ireland is still full of fight, although all his ribs are showing through his skin. It was by means as simple, and as direct as these that Daumier was able to make himself understood.

Bibliography

Adhémar, Jean, *Honoré Daumier*, Paris, 1954

Alexandre, Arsène, *Honoré Daumier, l'homme et l'œuvre*, Paris, 1888

Bellanger, Claude, *Histoire générale de la presse française*, Paris, 1969

Bouvy, Eugène, *Daumier, l'œuvre gravé du maître*, Paris, 1933

Cherpin, Jean, *l'Homme Daumier*, Marseilles, 1973

Articles by Adhémar, Cherpin, Ph. Roberts-Jones, Lecomte, etc., in *Aesculape*, Paris; *Arts et Livres de Provence*, Marseilles; *Gazette des Beaux-Arts*, Paris

Dollfus, Charles and Edgar de Geoffroy, *Histoire de la locomotion terrestre, les chemins de fer*, Paris, 1935

Heine, Heinrich, *Lutèce*, Paris, 1861

Larousse, Pierre, *Grand Dictionnaire universel du 19e siècle*, Paris, 1866-1877

Maison, K. E., *Catalogue raisonné of the paintings, watercolours and drawings*, New York, 1967

Simond, Charles, *Paris de 1800 à 1900*, Paris, 1900-1901

Texier, Edmond, *Tableau de Paris*, Paris, 1852, 1853

Vapereau, Gustave, *Dictionnaire universel des contemporains*, Paris, 1858 and 1870

Vincent, Howard P., *Daumier and his world*, Evanston, 1968

Wasserman, Jeanne L., *Daumier sculpture*, Fogg Art Museum, Harvard University, cat., 1969

Chronological background to Daumier and his times

1808 Born at Marseilles on 26 February
1816 The Daumier family settled in Paris
1821 First job as a bailiff's assistant
1822 First lithograph

1830-1848 Reign of King Louis-Philippe

1830 Freedom of the press
1832 Contributor to *La Caricature* and *Le Charivari*
 Commission to model small busts
 Imprisonment in political prison
1834 April rising, massacre in rue Transnonain
1835 Censorship; publication of *La Caricature* ceased
1837 Opening of Paris-St Germain railway
1846 Married Marie-Alexandrine d'Assy, seamstress

1848-1852 Second Republic

1848 Freedom of the press
 More time for painting; official commissions
 Louis Napoleon elected President for four years
1851 'Ratapoil'
 Coup d'état of 2 December; presidency extended to
 ten years; censorship

1852-1870 Reign of Emperor Napoleon III

1853 Haussmann to modernise Paris
1855 First World Exhibition in Paris

1860-1863	Contract with *Le Charivari* broken
	Vain attempt to make a living out of painting
	11 lithographs contributed to *Le Boulevard*
1863	Once again a regular contributor to *Le Charivari*
1865	Country cottage at Valmondois
1868	Freedom of the press
1870	19 July, start of Franco-German War
1870-	Third Republic
1870-1871	Siege of Paris, Commune
1871	Peace of Frankfurt, 10 May
1872	Eye disease, left *Le Charivari*
1874	Purchase of house at Valmondois
1878	General exhibition at Durand-Ruel's
1879	Died at Valmondois on 11 February

Plates

Abbreviations

D Loys Delteil, cat. des lithographies, 1926-1930
G Maurice Gobin, *Daumier sculpteur*, 1952

D 1297 Monsieur, je souscris pour le tremblement de terre 1
Charivari 1.10.1844

Daumier was in the habit of drawing himself, his wife Didine, and his friends in his caricatures. His own appearance was that of an extremely ordinary bourgeois, with a 'Newgate fringe' and a turned-up nose, but the look in his eyes was exceptionally sharp. Here he is a shopkeeper making a contribution towards a fund for the victims of an earthquake. In return for a gift of two francs he expects the name of his business and the full range of his wares to be clearly stated.

—Pouvez vous me recevoir a diner ces jours-ci?
—J'aimerais mieux aller diner chez vous si ça ne vous derange pas

D 2353 Pouvez-vous me recevoir à diner . . . **2**
Charivari 3.5.1853
Daumier had a visual memory and never drew from Nature. He managed
to conjure up memories of all kinds of different people, people he had seen
at the theatre, in 'salons' and cafés, at the Palace of Justice, in Parliament,
at the swimming-baths, on the train, in their homes and on the Seine.
The streets, however, were his principal source of inspiration.

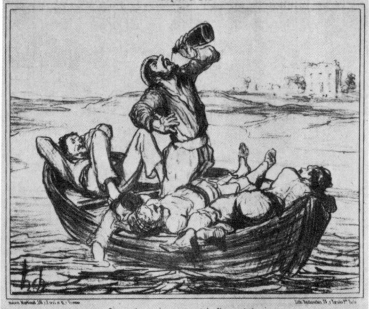

Descendant joyeusement le fleuve de la vie.

D 2845 **Descendant joyeusement le fleuve de la vie** 3
Charivari 7.8.1856
There was nothing Daumier liked better than drifting downstream in
pleasant company. A close look will also reveal a young woman who was
usually seated at the tiller.

D 627 **Ce matin avant l'aurore** 4
Charivari 9.6.1839
The small boy reciting a poem to wish his father a happy birthday, has
also brought a garland of flowers and a few studies of eyes such as Daumier
had been made to draw time and time again when he was a student.

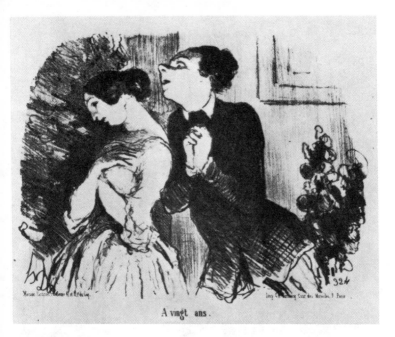

A vingt ans.

D 2396 **A vingt ans** 5
Charivari 27.4.1853
WHEN YOU ARE TWENTY
In this period, Daumier depicted his characters lit from below, as if they were on the stage.

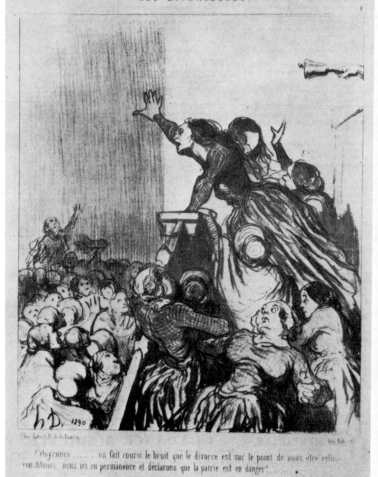

LES DIVORCEUSES.

Citoyennes on fait courir le bruit que le divorce est sur le point de nous être retiré... constituons nous ici en permanence et déclarons que la patrie est en danger!...

D 1769 **Citoyennes . . . on fait courir le bruit** 6
Charivari 4.8.1848
THE EMANCIPATION OF WOMEN
Nineteenth century women's libbers crowd round the rostrum.

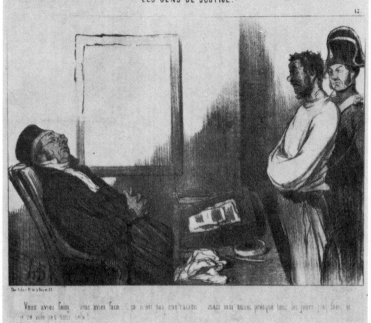

D 1351 **Vous aviez faim . . . ce n'est pas une raison** 7
Charivari 20.10.1845

'You were hungry, but that's no excuse. I too get hungry every day, but I don't go stealing.' Daumier had been acquainted with the Palace of Justice ever since his 13th year. This series, 'Les Gens de Justice' (Officers of the Law), and the inhumanity of judges in particular, touched him deeply.

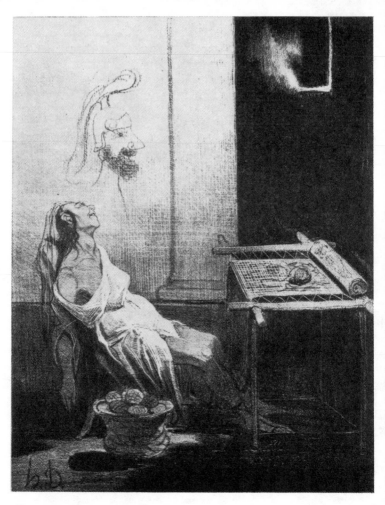

D 930 **Les nuits de Pénélopé** 8
Charivari 24.4.1842
THE NIGHTS OF PENELOPE
I. Before the return of Odysseus

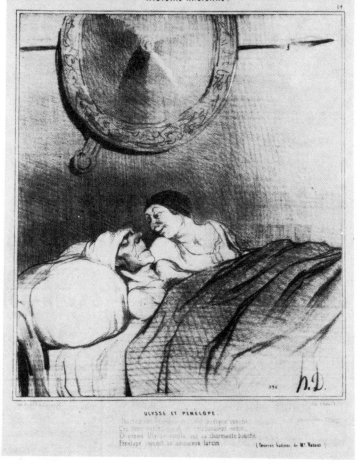

D 938 Ulysse et Pénélopé
Charivari 26.6.1842
THE NIGHTS OF PENELOPE
II. After the return of Odysseus

9

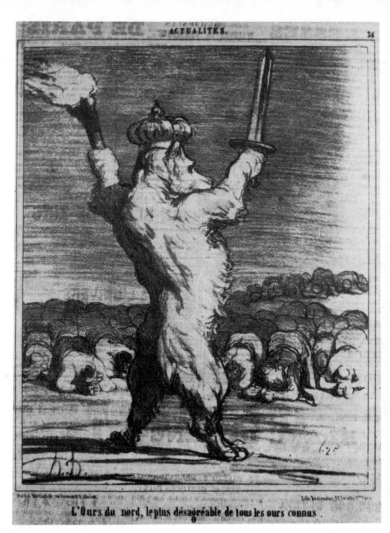

L'Ours du nord, le plus désagréable de tous les ours connus.

D 2493 l'Ours du nord 10
Charivari 17.4.1854
Between 1851 and 1868 political prints were only allowed when it suited
the government of Napoleon III, for example during the Crimean War.
The Russian bear brandishing torch and sword against the prostrate
peasantry has, in this lithograph, developed into a symbol of the imperial
dictator.

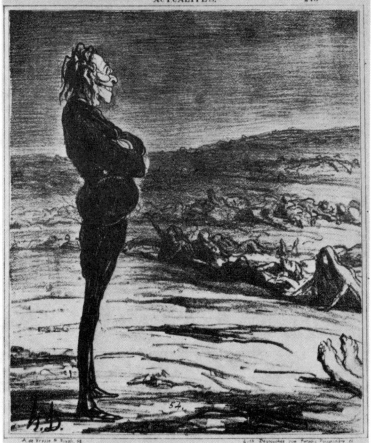

Le rêve de l'inventeur du fusil à aiguilles,
le jour de la Toussaint

D 3535 **Le rêve de l'inventeur du fusil à aiguilles** 11
Charivari 1.11.1866
The French Army had been equipped with a new and deadly weapon:
the Chassepot rifle. The newspapers were full of it. Here the inventor is
seen dreaming of the battlefield.

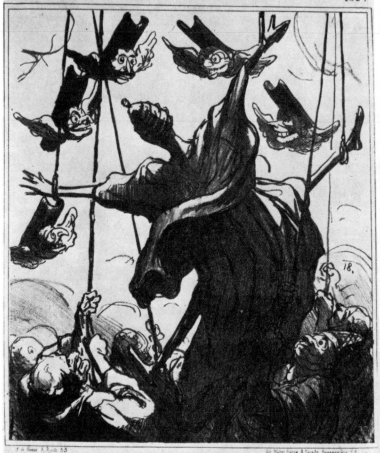

LA NOUVELLE ASSOMPTION
Édition de 1870.

D 3783 **La nouvelle assomption—édition de** 1870 12
Charivari 18.5.1870
An unfamiliar print of an event with far-reaching consequences. It
represents the Pope, suspended like a puppet and surrounded by winged
heads of Jesuits. The actual subject was the proclamation of the infallibility
of the Pope by the Vatican Council in 1870.

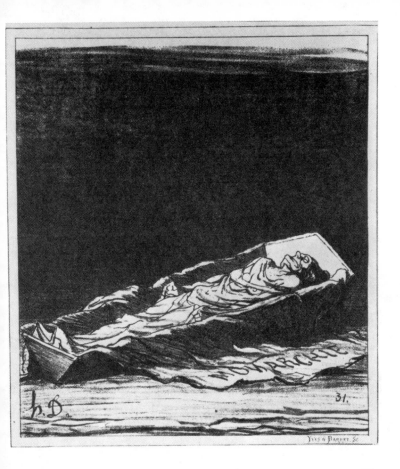

D 3937 **Et pendant ce temps-là ils continuent à affirmer** 13
Charivari 24.9.1872

THE MONARCHY IS DEAD

In 1872 there was a great deal of activity in France amongst the pretenders
to the throne. Orleanists and supporters of the Bourbons were moving
towards a merger. A nephew of Napoleon III was expelled from the
country. Daumier had no use for any kind of monarchy.

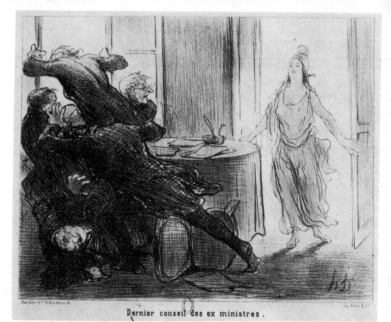

Dernier conseil des ex ministres.

D 1746 Dernier conseil des ex-ministres 14
Charivari 9.3.1848

When Louis-Philippe was compelled to abdicate, Daumier felt highly elated, as can be seen from this print. During the final meeting of the Cabinet, the doors fly open and the Republic appears. The ministers, looking like a tangle of writhing snakes, try to escape through the window. Prime Minister Thiers is recognisable by his spectacles.

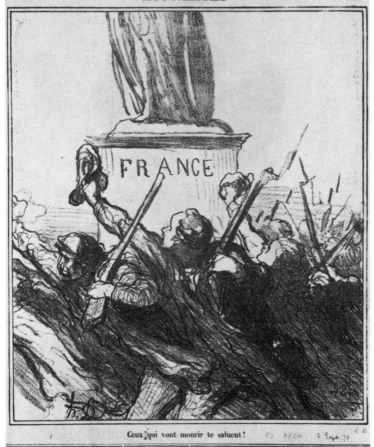

Ceux qui vont mourir te saluent !

D 3804 Ceux qui vont mourir te saluent **15**
Charivari 2.9.1870
War with Germany broke out on 19 July 1870. By the first days of
September the enemy was already alarmingly close to Paris. As volunteers
marched to the front, there was an upsurge of patriotic feeling in Paris
which Daumier expressed in vibrating lines.

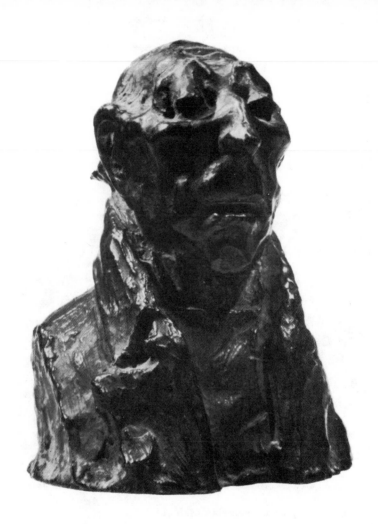

G 3 J. C. Fulchiron 16
Modelled in clay in 1833, cast in bronze in 1929
THE POLITICIAN
One of the small busts modelled by Daumier in 1832 and 1833. Over the
years the unfired clay shrank, cracked, and crumbled, and occasionally an
ear or a nose dropped off. Fortunately the original clay model of Fulchiron
was still almost intact when it was cast in bronze in 1929.

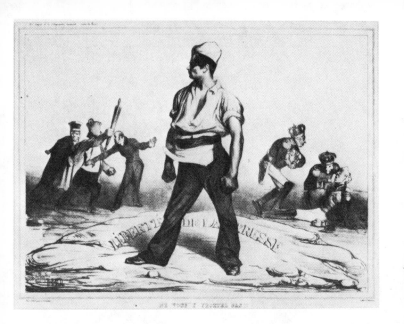

D 133 Ne vous y frottez pas 17
l'Assoc. Mensuelle 5.6.1834

THE TYPOGRAPHER

The freedom of the press cannot be curtailed. On the left, Louis-Philippe
with his umbrella, on the right, the previous king Charles X on the
ground.

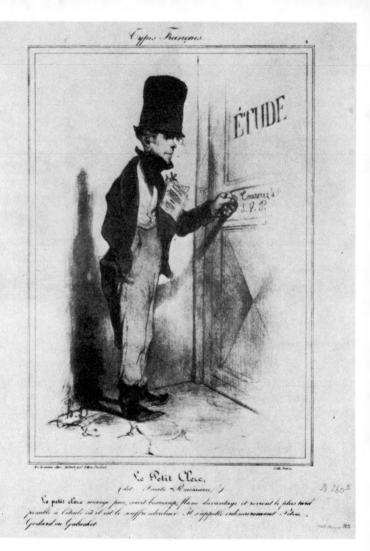

ÉTUDE

Le Petit Clerc,
(dit: Saute-Ruisseau.)

Le petit clerc mange peu, court beaucoup, flâne davantage et revient le plus tard
possible à l'étude où il est le souffre-douleur. Il s'appelle ordinairement Pierre,
Godard ou Galuchet.

B 260²

D 260 Le petit clerc, dit: saute-ruisseau 18
Charivari 23.9.1835
THE MESSENGER-BOY
Daumier's first job was as a bailiff's assistant at the age of 13. It made him
familiar with the Palace of Justice and the remotest corners of Paris. He
next worked in a large bookshop in the busy shopping centre by the
Palais Royal, and finally his parents agreed to his having drawing lessons.

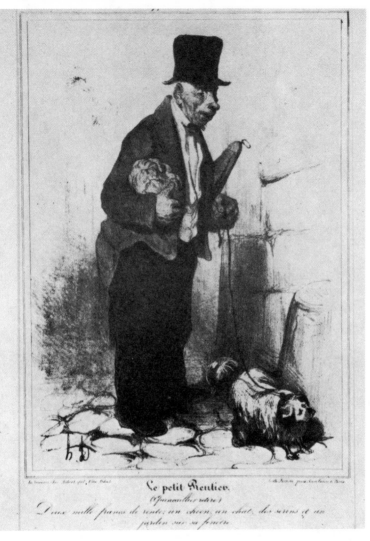

Le petit Rentier.
(Quincaillier retiré)
Deux mille francs de rente; un chien, un chat, des serins et un
jardin sur sa fenêtre.

D 264 Le petit rentier 19
Charivari 1.11.1835
THE SMALL RENTIER
The small rentier (retired ironmonger) prospered under the reign of the
Citizen-King.

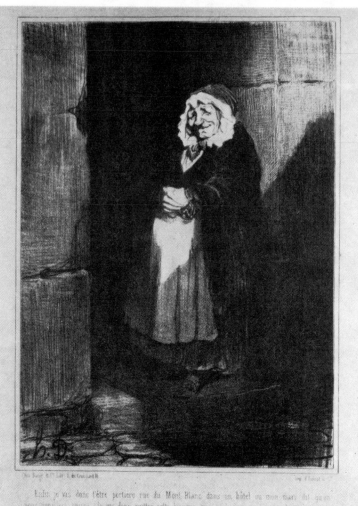

Enfin je vas donc l'être portière rue du Mont-Blanc dans un hôtel ou mon mari dit qu'on nous appellera suisse. Je vas donc quitter cette boutique ous qu'il n'y a que quatre locataires qui me donnent chacun cinq sous pour les étrennes..... Canailles !!!

D 836 **La marcheuse ou la garde-malade** 20
Charivari 22.5.1842
THE SICK-NURSE
A year later this drawing served as a model for the midwife Sarah Gamp
in the illustration by Phiz to Charles Dickens' *Martin Chuzzlewit*

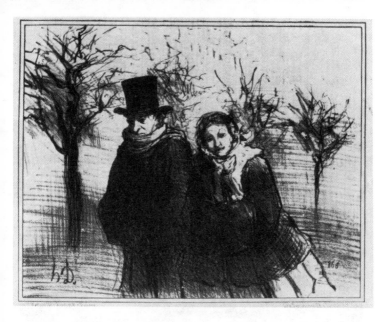

D 2798 **Mon ami, tu ne sais pas . . .** 21
Charivari 15.3.1856
The text is not in keeping with this masterly drawing of a married couple,
no longer young. Daumier could, with equal ease, convey a suggestion
of heat or cold, rain or snow, early morning light or a starlit sky.

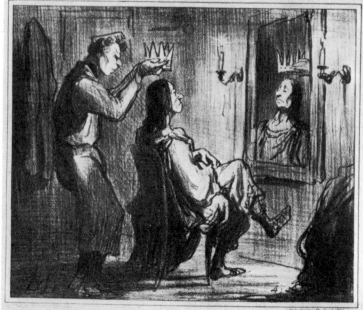

Agamemnon se faisant couronner à huis-clos. _Cérémonie dont la simplicité n'exclut point une certaine majesté.

D 2902 **Agamemnon se faisant couronner** 22
Charivari 23.12.1856
THE ACTOR AND THE THE THEATRICAL HAIRDRESSER
'King Agamemnon has himself crowned. A simple ceremony, not lacking in a certain dignity.' The hairdresser has a comb in his hair.

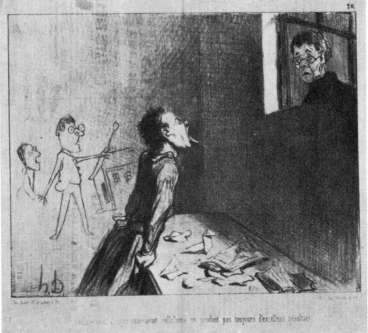

D 1457 **Comme quoi l'emprisonnement cellulaire** 23
Charivari 23.3.1846
THE PEDAGOGUE
Recalcitrant pupils were locked up in the cell behind the schoolroom, but
the desired effect was not always achieved. The school and the school-
master with his cane have been drawn on the wall. Nothing has come of
the work that had been set. One piece of paper has been folded into the
shape of a bird.

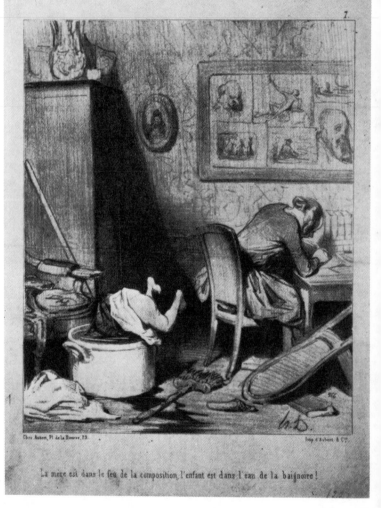

LES BAS-BLEUS.

La mère est dans le feu de la composition, l'enfant est dans l'eau de la baignoire!

D 1227 **La mère est dans le feu de la composition** 24
Charivari 26.2.1842
THE BLUE-STOCKING
The authoress neglecting her maternal duties always went down well in
the satirical press.

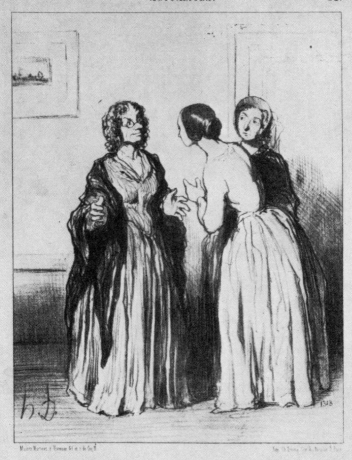

— 1ᵉʳ Bas bleu. — Profitons de l'occasion... L'Oncle Tom est à la mode... hâtons-nous d'écrire
un roman intitulé La Tante Tom.
— 2ᵉ Bas bleu — Ça me botte !...

D 2340 **1er bas bleu - profitons de l'occasion** 25
Charivari 19.11.1852
THE BLUE-STOCKING
The year 1852 saw the publication of *Uncle Tom's Cabin* by Harriet
Beecher-Stowe, which launched an attack on the 'divine institution' of
slavery. It immediately became a bestseller, which was a good reason for
these blue-stockings to write a book entitled *Auntie Tom's Cabin*.

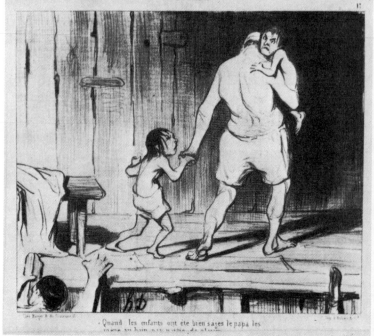

D 777 Quand les enfants ont été bien sages 26
Charivari 6.9.1840
THE BATHERS
When the children had been very good they were allowed to go to the
swimming baths with their father.

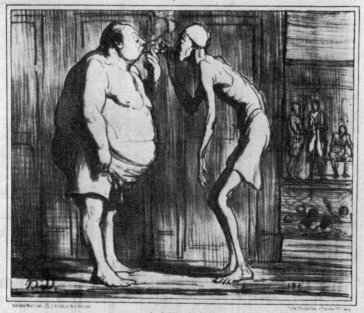

Après l'eau, le feu.

D 2869 **Après l'eau le feu** 27
Charivari 7.7.1858
THE BATHERS
There were two kinds of swimming baths in the Seine: luxurious
establishments in the oriental style, and popular baths (admission 'à 4-
sous') which Daumier visited regularly. From the roof of his home at
quai d'Anjou no. 9 he could see into one of these swimming baths.

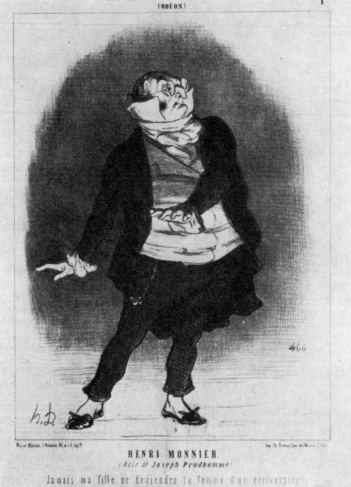

HENRI MONNIER.
(Rôle de Joseph Prudhomme)
Jamais ma fille ne deviendra la femme d'un écrivassier!

D 2347 Henri Monnier (rôle de Joseph Prudhomme) 28
Charivari 13.12.1852
MONSIEUR PRUDHOMME
Henri Monnier, an old friend of Daumier's, was a caricaturist, playwright and actor. His best-known creation was Joseph Prudhomme, a man of substance with strongly held views, and a specialist in commonplace utterances.

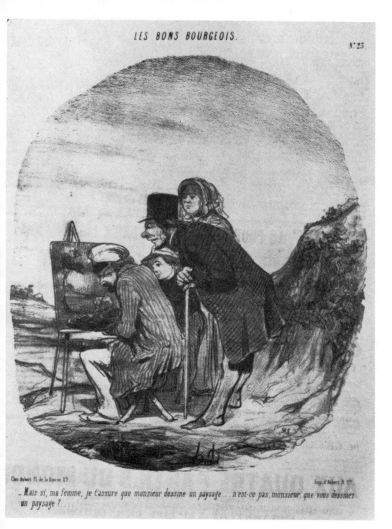

_ Mais si, ma femme, je t'assure que monsieur dessine un paysage... n'est-ce pas, monsieur, que vous dessinez un paysage ?...

D 1499 **Mais si, ma femme . . . monsieur dessine un paysage** 29
Charivari 13.11.1846
THE PAINTER

A painter working out of doors was still a curiosity in 1846. Daubigny, one of Daumier's most faithful friends, frequently complained about the annoying interest shown by passers-by when he was working in the open air.

Je crois qu'on bat le rappel Adolphe n'y vas pas au nom des enfans que nous
auriens pu avoir !

D 1767 Je crois qu'on bat le rappel 30
Charivari 3.6.1848

THE MILITIA

Anyone liable to direct taxation and able to afford the uniform, could
become a member of the Garde Nationale (the militia). The price of the
uniform was 48 francs, not including weapons. When the alarm was
sounded, the Garde Nationale had to go into action. 'Adolphe, don't go . . .
in the name of the children we might have been able to have.'

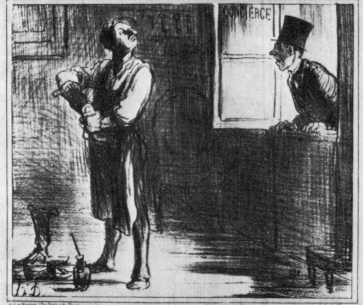

— Monsieur a-t-il un état monsieur, travaille-t-il ? ... — Oui , je suis homme de lettres'
— Alors c'est inutile que je vous fasse voir le logement notre maison est très bien tenue , nous
ne louons pas à des gens qui ont un état c'est trop bruyant !

D 2922 **Monsieur a-t-il un état ...** 31
Charivari 14.2.1857
THE CONCIERGE
Daumier moved house a great deal and many of his prints show a pro-
found dislike of concierges. This one, interrupted while in the midst of
cleaning boots, informs a man of letters in search of an apartment that
only gentlemen of leisure are tolerated in *his* house.

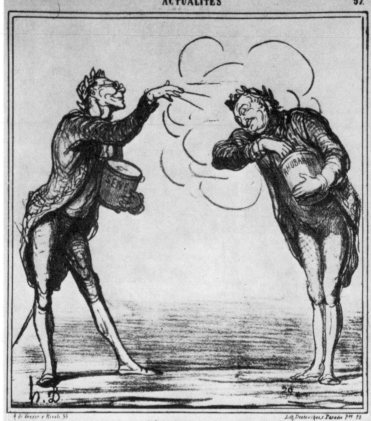

Réception académique.

D 3636 **Réception académique** 32
Charivari 24.4.1868
MEMBERS OF THE ACADEMIE FRANCAISE
Inaugural reception for a new Member. The senna and rhubarb, both
purgatives, used by Members perfuming each other with incense, are an
allusion to a play by Moliere which Daumier knew very well.

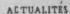

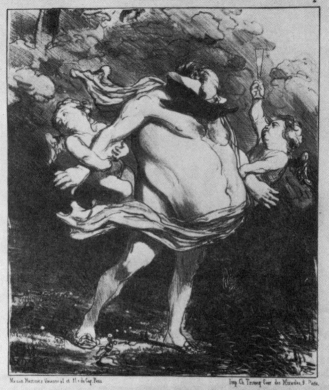

Le docteur Véron refusant toute espèce de consolation.

D 2258 Le Docteur Véron refusant . . . consolation 33
Charivari 9.7.1852
THE BUSINESSMAN
Women and wine cannot console Dr Véron. The doctor had made a lot of
money with an ointment for the chest and a large daily newspaper, but
now he had lost favour with President Louis Napoleon. According to his
enemies he wore a high collar to conceal his pimples.

LE DÉSESPOIR DES BOUCHERS.
— Dire que prochainement le premier venu pourra s'établir boucher!..... ah!...il y a des moments où j'ai ...

D 3013 Le désespoir des bouchers 34
Charivari 21.11.1857
THE BUTCHER
A butcher's despair at the shattering news that the butchers' monopoly
is to be abolished, and the grocer on the corner will soon be able to sell
meat. Another print showing butchers making sausages (from cats and
dogs) was rejected by the censor, as this revolting subject would stop people
ever wanting to eat meat products again.

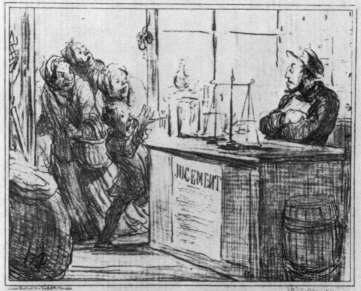

Condamné pour avoir vendu du grès pilé au lieu de cassonnade.

D 2765 **Condamné pour avoir vendu du grès pilé** 35
Charivari 7.12.1855
THE GROCER
Local residents come and torment the grocer who adulterated his goods.
The sentence is glued to the counter.

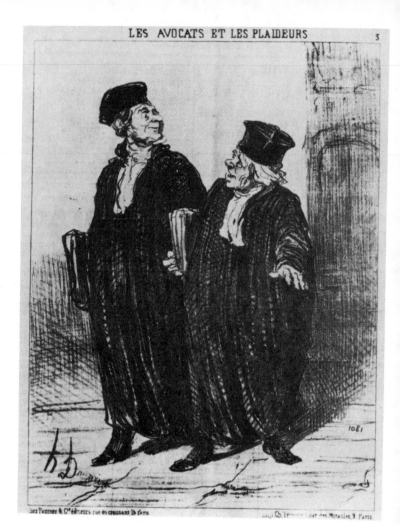

D 2187 **Enfin! nous avons obtenu la séparations de biens** 36
Charivari 3.12.1851
THE ADVOCATE
'At last we have managed to divide the couple's property!' 'About time
too, the court case has ruined them both!' Prosecuting and defending
counsel both fared badly with Daumier. He was slightly more tolerant
of judges, although they were inclined to fall asleep in the course of a
dramatic plea by Counsel.

ACTUALITÉS.

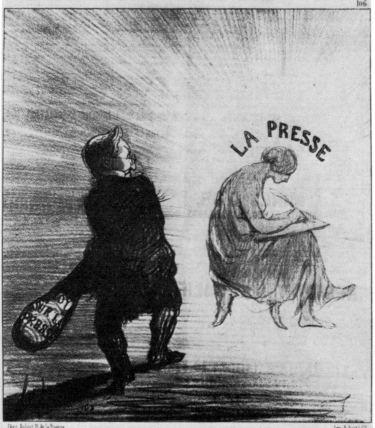

Un parricide.

D 2002 Un parricide 37
Charivari 16.4.1850
THE PRESS
The shrewd politician Thiers (drawn 111 times by Daumier) trying to
silence the press for good. The word 'parricide' was used here because
Thiers began his career as a journalist.

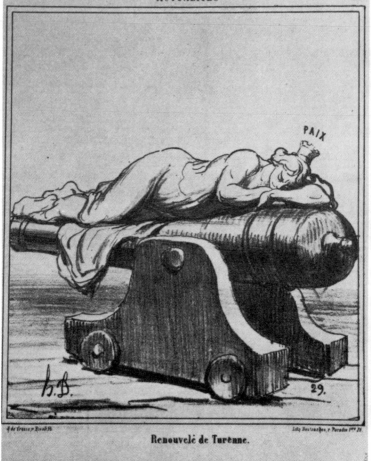

D 3644. **Renouvelé de Turenne** 38
Charivari 15.6.1868
PEACE
The armed peace of 1868 foreshadowed the Franco-German War.

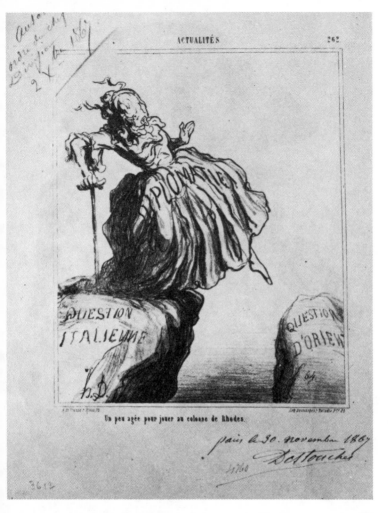

Un peu agée pour jouer au colosse de Rhodes.

D 3612 Un peu agée pour jouer au colosse de Rhodes 39
Charivari 10.12.1867

DIPLOMACY

French diplomacy was sadly inadequate in the final years of the Second Empire. The hand-written inscriptions are interesting. First of all, proofs were made of the drawing. When the frame and the text had been added, the printer (bottom right) and the Censor (top left corner) had to sign their approval before the definite printing, first on white paper for sale, and finally in the newspaper.

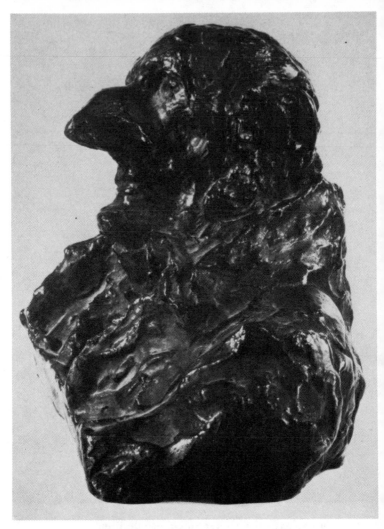

G 31 Comte d'Argout 40

Modelled in clay in 1832, cast in bronze in 1934. Daumier was com-
missioned to model the heads of Ministers and Government supporters.
Thirty-six of these small busts, which were meant as preliminary studies,
have been preserved. They were made of unfired clay and were restored
many times before finally being cast in bronze a hundred years later.

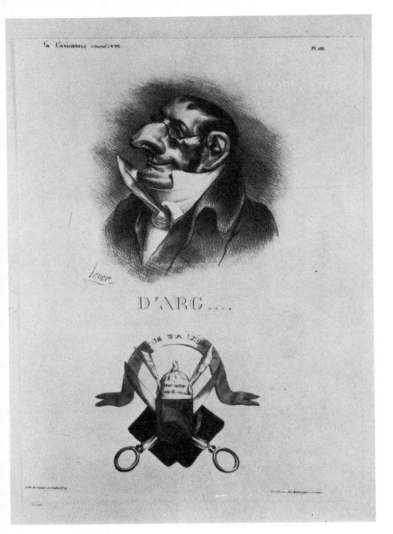

D 48 **Comte d'Argout** 41

Caricature 9.8.1832

Count d'Argout, Minister of Arts and Public Works, maltreated the French language. The escutcheon bears the motto, 'Everyone is entitled to massacre the language'. Note the Censor's scissors, which he wielded too generously, and the famous nose which was to become even larger in subsequent prints.

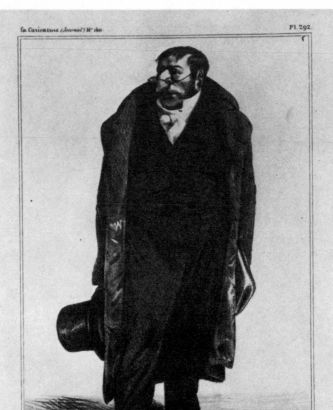

Pl. 292.

M. D'ARGO...

D 62 Comte d'Argout 42

Caricature 11.7.1833

Many of Daumier's clay models of politicians were first lithographed as busts, then full-length as in this illustration, and finally in groups. The final letters of the name (d'Argout) were omitted from the print so that the Public Prosecutor would have no grounds for action. In this print, as much care has been devoted to the clothes as to the posture, something Daumier always remembered exactly about all his victims.

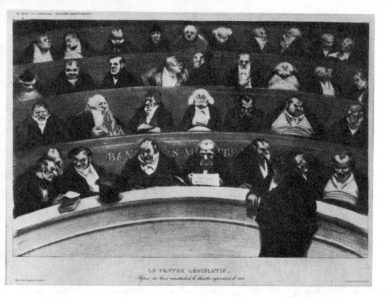

LE VENTRE LÉGISLATIF.

D 131 **Le ventre législatif** 43
l'Assoc. Mensuelle 13.2.1834
The faint arc of the Parliament benches is repeated in the abdominal
folds of Ministers (front row) and Deputies. Most of the politicians
Daumier had modelled are gathered here. Minister d'Argout, recognis-
able by his large nose, is third from the right in the front row. Large
prints like this one were published to help pay for fines and legal costs.

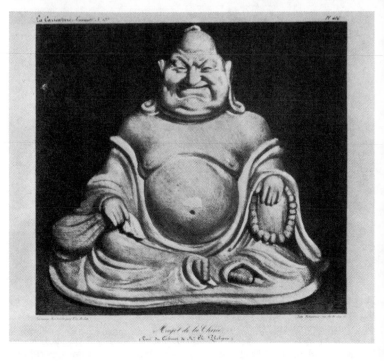

D 83 Magot de la Chine 44
Caricature 28.8.1834

LOUIS-PHILIPPE AS A CHINESE STATUETTE

One of the many variations on the theme of the pear. The King's head
is shown grinning above his rotund body. The large ears replace the
side-whiskers. In his right hand he is holding a money-bag, symbol of
corruption. Note the stem of the pear just visible above his forehead.

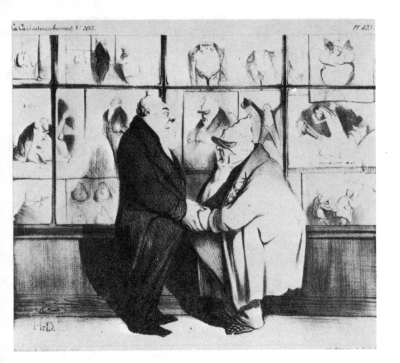

D 89 Où allons-nous 45

Caricature 27.9.1834

This is the print-shop and publishing company in the Passage Véro-Dodat, where Daumier's career started. Charles Philipon, artist and journalist, founded the business in 1829, together with his brother-in-law Aubert. In less than three years thousands of prints and two republican newspapers were published: the weekly *La Caricature* and the daily *Le Charivari*. In the window there are prints by Daumier as well as the drawing of the pear. In front of the shop are Deputy Etienne of *Le Constitutionnel* and, next to him, wearing a nightcap and eye-shade, the personification of this deadly dull conservative paper.

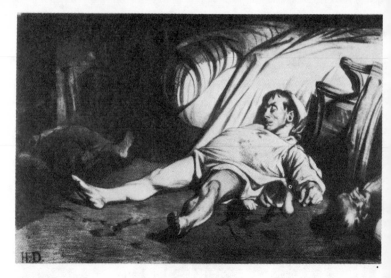

D 135 **Rue Transnonian, le 15 avril 1834** 46
l'Assoc. Mensuelle 2.10.1834

The massacre in the rue Transnonain. In the course of the bloody suppression of the silk-workers' rising at Lyons in 1834, barricades were, as usual, erected in Paris. On 14 April, soldiers forced their way into the house at rue Transnonain no. 12 after a shot had been fired from one of its windows. Ten innocent people were murdered with bayonets and sabres: eight men, a woman and a child.

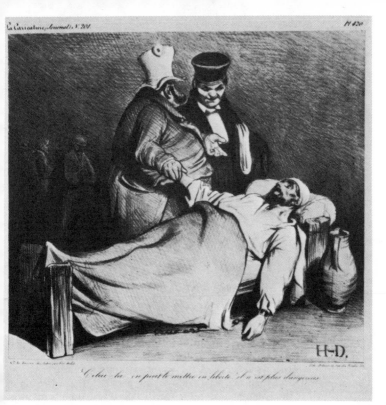

'Celui-là on peut le mettre en liberté, il n'est plus dangereux.'

H-D.

D 85 Celui-là, on peut le mettre en liberté **47**
Caricature 11.9.1834
After the revolt in April 1834, 1,500 people were arrested, a small
number of whom stood trial. Louis-Philippe considers this particular
political prisoner is no longer dangerous.

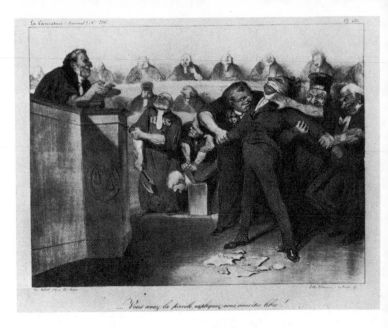

D 116 Vous avez la parole, expliquez-vous, vous êtes libre 48
Caricature 14.5.1835
ADMINISTRATION OF JUSTICE BY THE CHAMBRE DES PAIRS
The mass trial of 121 persons accused of taking part in the April rising of
1834 opened at the Luxembourg on 5 May, 1835. It lasted for 9 months.
In this illustration, one of the Defendants is being gagged, while another
is about to have his head cut off by a highly decorated Peer.

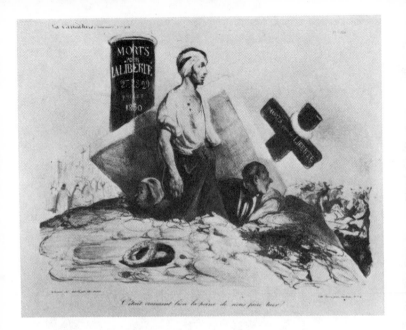

D 130 C'était vraiment bien la peine de nous faire tuer! 49
Caricature 27.8.1835
After an attempt on Louis-Philippe's life, when 18 people were killed,
nothing was left of the freedom of the press. In the final issue of *La
Caricature* the resurrected heroes of the July Revolution observe that
nothing has changed. On the left is a procession, on the right innocent
citizens are under attack.

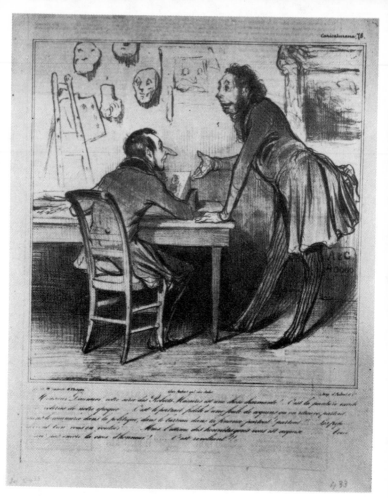

D 433 Monsieur Daumier, votre série . . . est . . . charmante 50
Charivari 8.4.1838

Elaborating on the theme of the popular stage character 'Robert Macaire' (a swindler), Philipon, director of *Le Charivari*, thought up a series of prints featuring Macaire in all kinds of professions. Daumier produced the drawings. In this print, Macaire comes to compliment the artist, who, after a proof had been made, was given Philipon's long nose.

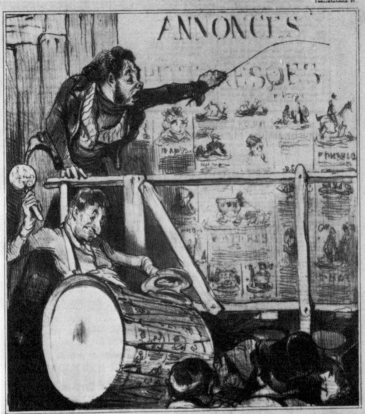

D 436 **Voulez-vous de l'or . . . des diamans** 51
Charivari 20.5.1838
AN EVERYDAY STREET SCENE
The two swindlers Robert Macaire and Bertrand show people how to
become rich quickly. There was money to be made out of asphalt, iron,
lead, gold, paper and sheet iron. Later on, partly as a result of freight
transport by rail, industrialisation was to get under way. This meant a
hey-day for the Stock Exchange and speculation.

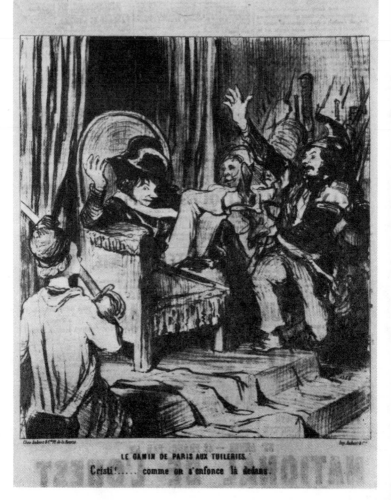

LE GAMIN DE PARIS AUX TUILERIES.
Cristi!..... comme on s'enfonce là dedans.

D 1743 **Le gamin de Paris aux Tuileries** 52
Charivari 4.3.1848

On 24 February 1848 Louis-Philippe abdicated and fled to England. The
rabble forced its way into the palace. A street urchin in a looted uniform
bounces about on the throne, which was later carried in procession
through the streets, and finally burned in the Place de la Bastille beneath
the column commemorating the heroes of the July Revolution of 1830.

-- Voilà une femme qui, à l'heure solennelle où nous sommes, s'occupe bêtement de ses enfans: qu'il y a encore en France des êtres abruptes et arriérés!

D 1770 **Voilà une femme qui, à l'heure solennelle** 53
Charivari 12.8.1848
DIVORCE AND WOMEN'S EMANCIPATION
Equal rights for women did not get very far in 1848. This print of two harridans expressing exasperation at the sight of a woman playing with her child, is typical of the attitude of both the press and Daumier.

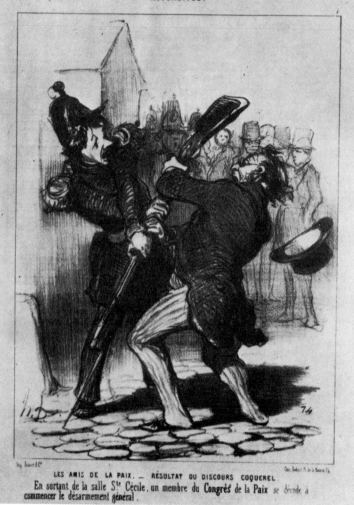

LES AMIS DE LA PAIX. — RÉSULTAT DU DISCOURS COQUEREL.

En sortant de la salle Ste Cécile, un membre du Congrès de la Paix se décide à commencer le désarmement général.

D 1904 Les amis de la paix 54
Charivari 1.9.1849
THE PARIS PEACE CONFERENCE OF 1849
After an ardent plea by the peace-loving Pastor Coquerel, a worthy
delegate starts practising general disarmament.

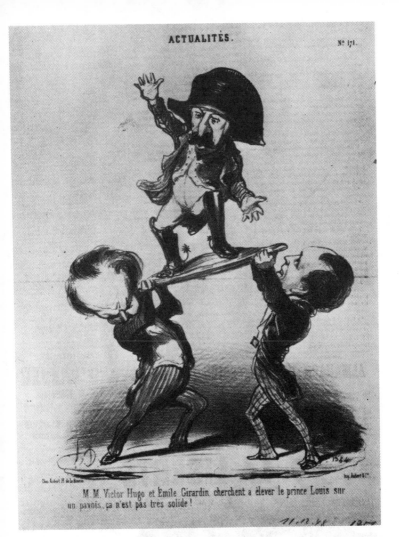

M. M. Victor Hugo et Emile Girardin cherchent a élever le prince Louis sur un pavois, ça n'est pas tres solide !

D 1756 **Victor Hugo et Emile Girardin cherchent a élever** 55
Charivari 11.12.1848
Against all expectations, Prince Louis Napoleon (nephew of the Emperor Napoleon), was elected President of the Second Republic on 10 December 1848. The Legitimist press, to which Victor Hugo (left) and the newspaper magnate Emile Girardin (right) belonged, was on his side. Three years later Girardin was exiled. Hugo fled abroad, and for 18 years made fierce attacks on 'Napoleon the Small'.

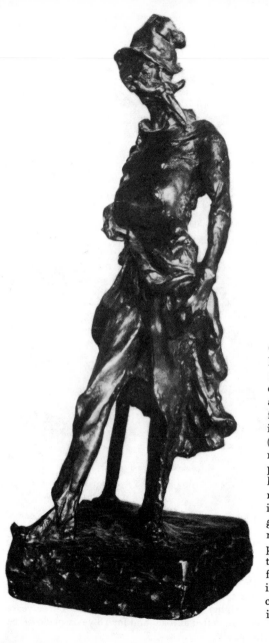

56

G61 **Ratapoil**
Modelled in clay in
1851, cast in plaster
of Paris shortly
afterwards, and
finally cast in bronze
in 1891. Ratapoil
(rat-à-poil),
representative of the
police state, rests on
his cudgel. Daumier
modelled this figure
in great detail and
gave it Napoleon III's
moustaches and
pointed beard. After
the coup d'état the
figure was wrapped
in a straw bottle
cover and concealed
in a lavatory.

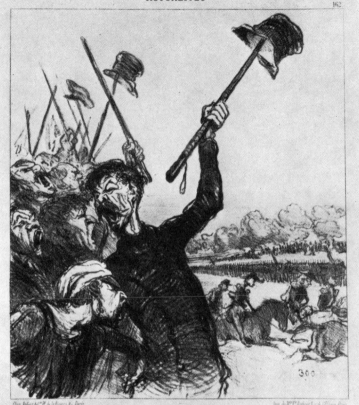

ACTUALITÉS

UN JOUR DE REVUE.

RATAPOIL ET SON ÉTAT MAJOR — Vive l'Empereur !

D 2123 **Un jour de revue** 57
Charivari 1.7.1851

It is several months before President Louis-Napoleon's coup of 2 December 1851, the first step on the way to the Imperial throne. To achieve this goal, secret agents (Ratapoil and his henchmen) mingled with the crowds during parades to shout 'Vive l'empereur'.

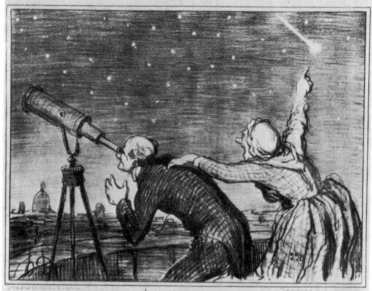

Monsieur Babinet prévenu par sa portière de la visite de la comète

D 3080 **Monsieur Babinet prévenu par sa portière** 58
Charivari 22.9.1858
This is Monsieur Babinet, Member of the Academy of Science, and
famous for his popular lectures. What a pity he happened to be looking
in the wrong direction when the comet he had predicted appeared in the
skies!

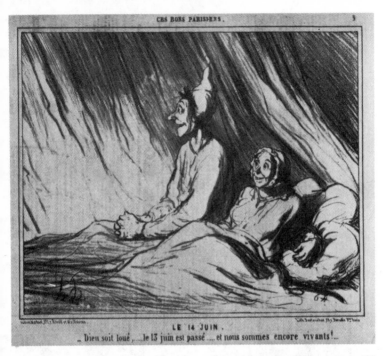

LE 14 JUIN.

_ Dieu soit loué,....le 13 juin est passé..... et nous sommes encore vivants!...

D 2657 **Le 14 juin** 59
Charivari 15.6.1857
Parisians became extremely agitated when comets appeared. The tail
alone was supposed to be enough to burn up every living creature on
earth. God be praised, the fatal date has passed and this couple is still alive.

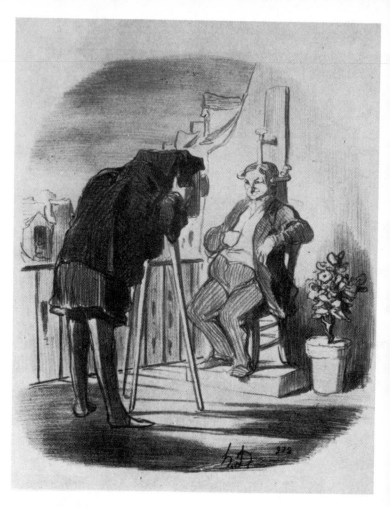

D 1525 Position réputée ... pour ... un portrait de daguerrotype 60

Charivari 24.7.1847

THE EARLIEST PHOTOGRAPHS

For an attractive portrait, the sitter's face was powdered white, and his head and neck were clamped into position. He then had to sit in the bright sunlight for twenty to ninety seconds without moving.

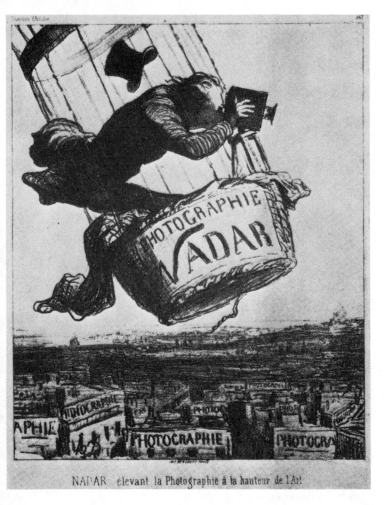

NADAR élevant la Photographie à la hauteur de l'Art

D 3248 Nadar élevant la photographie à la hauteur 61
Boulevard 25.5.1862
The red-haired Nadar (pseudonym for Félix Tournachon), balloonist,
photographer, journalist and caricaturist, was one of the most striking
personalities in nineteenth century Paris. He made a large number of
portraits of famous contemporaries, including Daumier, and also took
the first photograph from a balloon.

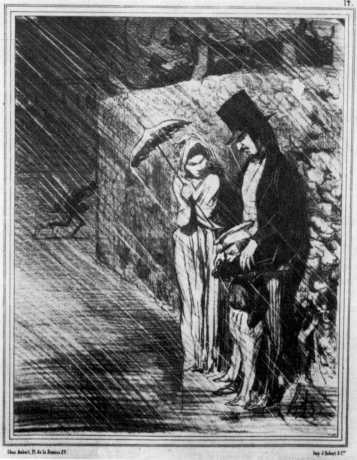

D 1285 **Grandes eaux à Versailles** 62
Charivari 28.7.1844
Parisians' first experience of the railways was in 1837 when a line to
St Germain was opened; the trip took 26 minutes. Two railway links
with Versailles followed, and Louis-Philippe had the Palace renovated.
The ornamental waterworks and fountains in the Park ('Les grandes
eaux à Versailles') were the greatest attraction.

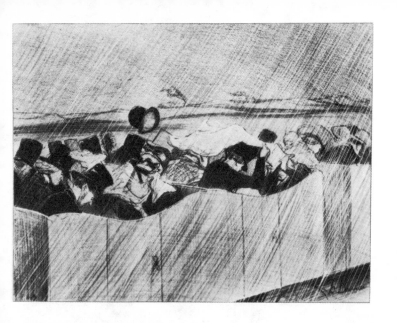

D 1048 Un voyage d'agrément de Paris à Orléans 63
Charivari 7.7.1843

On 2 May 1843 the first important railway line from Paris to Orleans
was opened. The journey took four hours. Third-class passengers travelled
in open carriages and were exposed to all weather conditions during this
pleasure trip. Spectacles were on sale at stations to protect the eyes from
grit.

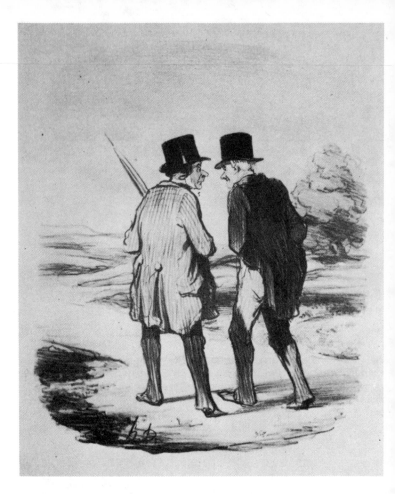

D 2365 **Oui . . . Rifolet . . . on dit que les cosaques**　　　　64
Charivari 28.6.1853
THE COUNTRY WALK
When the printing ink had been applied to the lithographic stone, a few
proofs were pulled first. This is one of them. Daumier simply made a
drawing of two gentlemen enjoying a chat, and the text-writer had to
think up a topical caption.

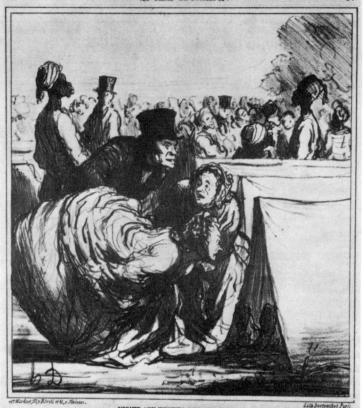

VISITE AUX TENTES DES TURCOS.
– Tiens !... ils dorment comme des hommes ordinaires

D 3192 **Visite aux tentes des Turcos** 65
Charivari 13.8.1859
Places of interest outside the city. Algerian army units (Turcos) were
encamped at St Maur des Fossées on the Marne. How strange that Turcos
could sleep just like ordinary human beings!

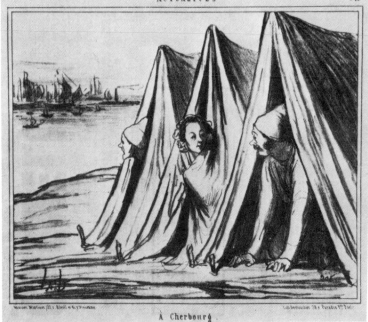

À Cherbourg.

D 3061 A Cherbourg
Charivari 11.8.1858

66

THE FIRST CAMPERS

The railways provided a fresh impetus to tourism and the building of large hotels. But some time elapsed before there was adequate hotel accommodation to cater for the influx of visitors. When the railway was extended to Cherbourg in 1858, these Parisians, who wanted to watch the great review of the fleet, took military tents with them.

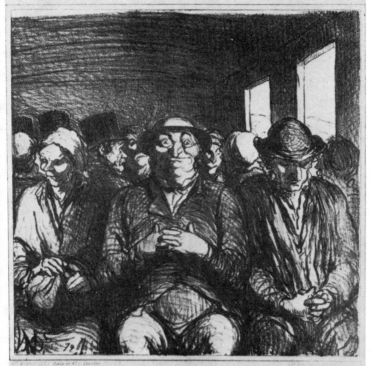

M PRUD'HOMME. Vive les wagons de troisième classe on peut y être asphyxié mais jamais assassiné

D 3299 **M. Prud'homme - Vive les wagons de troisième** 67
Charivari 30.8.1864

In 1864 a passenger was shot dead in a first class compartment. From then onwards Monsieur Prud'homme travelled third class as he preferred suffocation to being murdered. Daumier used the theme of railway passengers for a number of paintings and drawings.

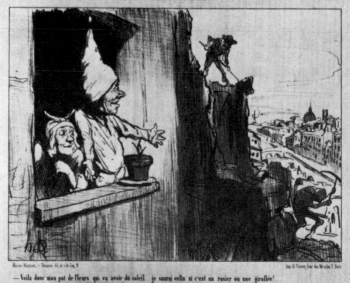

— Voilà donc mon pot de fleurs qui va avoir du soleil. je saurai enfin si c'est un rosier ou une giroflée!

D 2276 **Voilà . . . mon pot de fleurs . . . va avoir du soleil** 68
Charivari 18.12.1852
Napoleon III appointed Haussmann Prefect with instructions to change
the face of Paris. Wide thoroughfares were built and lined with trees
and uniform apartment blocks. The lay-out also facilitated the movement
of troops in the event of riots. Demolition work for the extension to the
Rue de Rivoli started as early as 1852, and this couple was now able to
see the Seine and give their potted plant some sunshine at last.

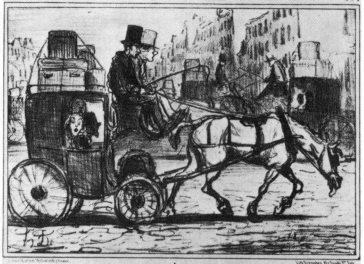

AOÛT 1855.
Plan, coupe, hauteur et élévation d'une voiture de place de Paris.

D 2701 **Août 1855** 69
Charivari 4.9.1855
On 15 May 1855 Paris was ready for the first World Exhibition on French
soil. It attracted five million visitors, including Queen Victoria. Tourists
arriving by train could hardly believe their eyes when they saw the new
metropolis. Paris was being changed out of all recognition.

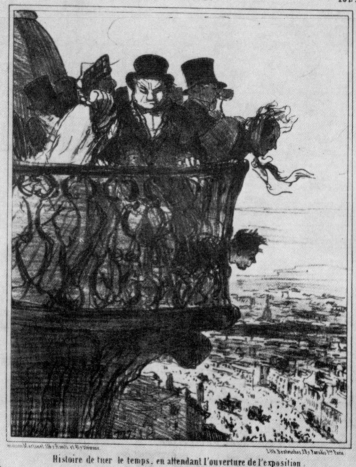

Histoire de tuer le temps, en attendant l'ouverture de l'exposition.

D 2709 **Histoire de tuer le temps** 70
Charivari 15.5.1855

When the World Exhibition opened, all the international railway links
had been completed, and so had the Grand Hotel du Louvre in the Place
du Palais Royal. There were a great many things for strangers to see
apart from the Exhibition—it frightened one to death to look down from
the viewing platform of the column commemorating the heroes of the
July Revolution in the Place de la Bastille.

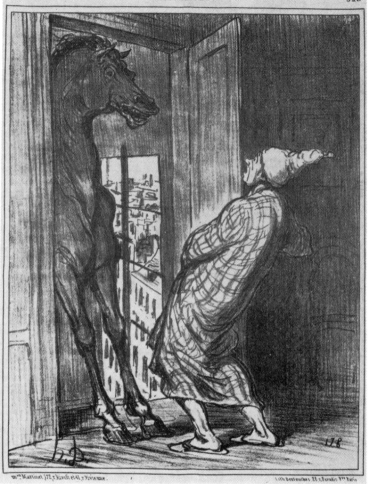

D 3048 **Plaisanterie que se permettent . . . les chevaux** 71
Charivari 22.5.1858
A true story. A horse walked into a newly built house in the Rue de
l'Etoile and, to the consternation of its occupants, up the stairs to the
fifth floor.

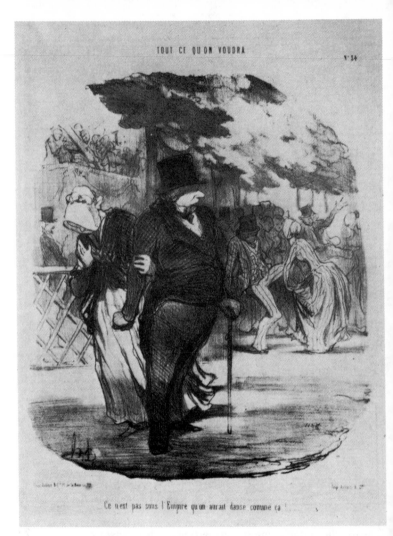

Ce n'est pas sous l'Empire qu'on aurait dansé comme ça !

D 1680 Ce n'est pas sous l'empire qu'on aurait dansé comme ça 72
Charivari 17.10.1849
'Such things would not have been allowed in my day.' The can-can was
danced individually and with tremendous élan; like rock-and-roll a
century later, it did not find favour with the older generation.

La Muse de la Brasserie

D 3260 **La muse de la brasserie** 73
Charivari 21.1.1864.

For three years Daumier tried in vain to make a living out of painting
alone. On his return to *Le Charivari* in 1863, he started with a series of
prints of the large cafés frequented by journalists, artists and politicians.
His friend Courbet drank large quantities of beer, Daumier himself
preferred wine, and for serious drinkers there was a new drink: absinth.

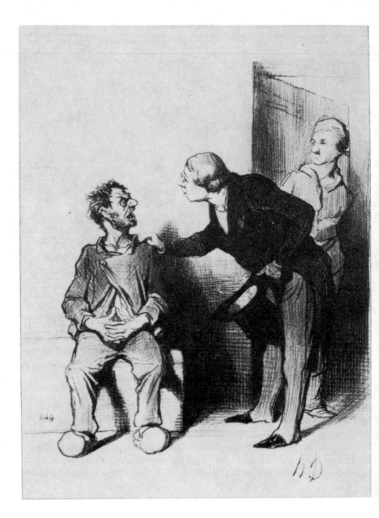

D 1293 **Je suis content de notre nouveau** 74

Charivari 16.9.1844

The gentleman taking an interest in the reform of the prison service, is
specially pleased with the new cell system. Solitary confinement has
completely dulled the prisoner's senses; now rehabilitation can begin.

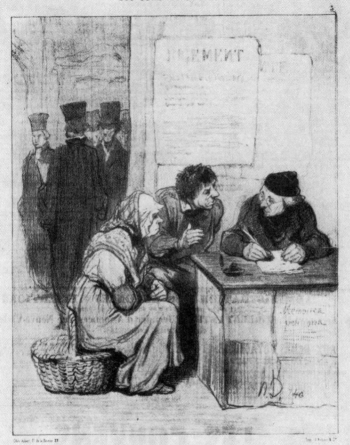

LES GENS DE JUSTICE.

- Faut-y faire une lettre pour l'attendrir?
- Attendrir un huissier! ... vous n'êtes donc pas français, mon brave homme?

D 1341 Faut-y faire une lettre pour l'attendrir? 75
Charivari 17.4.1845
The public letter-writer was a familiar figure at the Palace of Justice.
The farmer and his wife learn there is no point in writing a letter to the
bailiff in an attempt to make him relent.

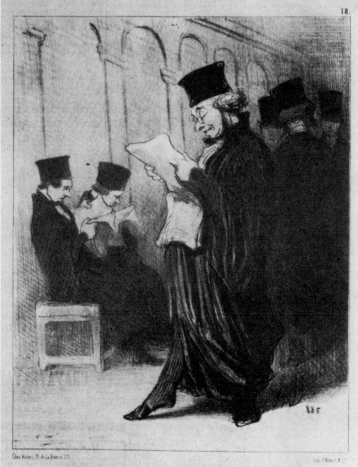

Maître Chapotard lisant dans un journal judiciaire l'éloge de lui même par lui même

D 1354. Maître Chapotard lisant - l'éloge de lui-même 76
Charivari 26.3.1846
In a legal journal Maître Chapotard reads flattering words about himself—
written by himself.

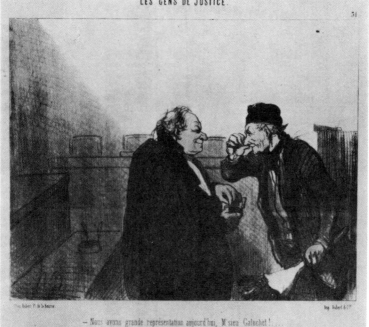

LES GENS DE JUSTICE.

— Nous avons grande représentation aujourd'hui, M'sieu Galuchet!....
— Parbleu j'crois bien un assassinat orné de viol!

D 1367 Nous avons grande représentation aujourd'hui **77**
Charivari 8.9.1847
Before the session. Today there is to be a gala performance: murder
embellished by rape.

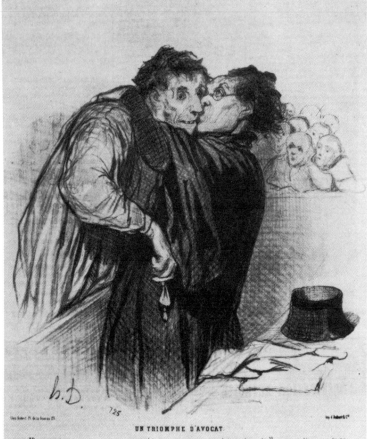

UN TRIOMPHE D'AVOCAT

Viens contre mon cœur, tu es acquitté! entre nous tu méritais bien d'aller aux galères car tu es
un fier gueux mais n'importe il est toujours bien doux de sauver ses semblables!

(Le voleur fort ému chippe la bourse de son défenseur, histoire d'emporter un souvenir d'estime et d'amitié)

D 1129 **Un triomphe d'avocat** 78
Charivari 23.2.1845
The acquitted thief takes advantage of the opportunity to steal his
Counsel's purse.

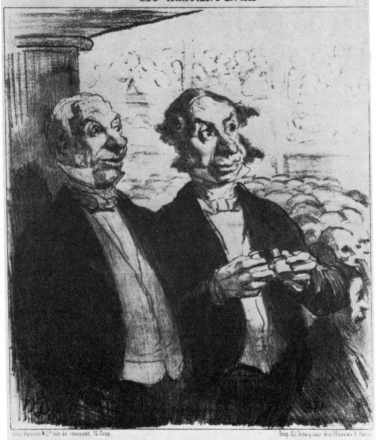

LES PARISIENS EN 1852

Se posant en appréciateurs de la bonne comédie.

D 2227 Se posant en appréciateurs 79
Charivari 26.2.1852

Interest in the theatre greatly increased after 1852. For Daumier this
was a fascinating subject. He no longer remained seated or standing
amongst the spectators, but also appeared on the stage, behind the scenes,
and in the dressing-rooms of friendly actors.

_ Dire... que dans mon temps, moi aussi, j'ai été une brillante Espagnole...... maintenant je n'ai plus d'espagnol que les castagnettes !.... c'est bien sec !.....

D 2907 **Dire, que dans mon temps, moi aussi** 80
Charivari 24.1.1857
All the mother of the 'Spanish dancer' can now do is play the castanets.

Rappelés avec enthousiasme !...... et pas un claqueurvoilà ce qui s'appelle un vrai succès..... et on dit

D 3042 **Rappelés avec enthousiasme** 81
Charivari 1.5.1858
During the Second Empire, amateur theatricals also flourished as never
before. The Empress Eugénie led the way. Charades, tableaux-vivants,
revues and plays were produced regularly by the Court at the Palace of
Compiègne.

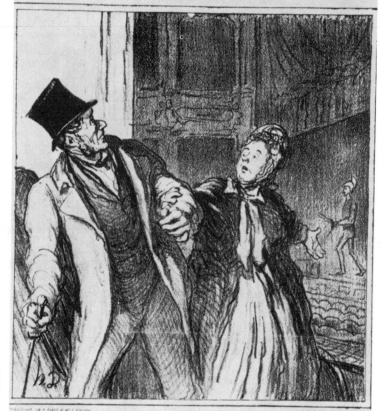

UNE MÉPRISE A L'ODÉON UN JOUR DE TRAGÉDIE

— Mais viens donc, mais viens donc !..
— J'te dis que ça n'est pas fini on vient de relever le rideau et voila encore un romai

D 3265 Une méprise a l'Odéon 82
Charivari 4.5.1864
Daumier was a keen theatre-goer, but rarely took his wife with him.
In this print the performance of a tragedy at the Odéon Theatre is just
over; most of the audience have left, and a fireman holding a lamp is
walking across the stage. It is time to go home, but the woman (Mme
Daumier) is convinced there is more to follow, as there is still a Roman
on the stage.

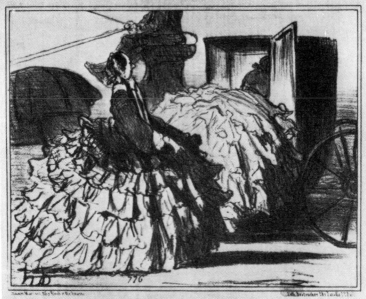

Des dames d'un demi monde, mais n'ayant pas de demi-jupes.

D 2624 Des dames d'un demi-monde
Charivari 11.5.1855

83

The crinoline was a slight steel construction, a kind of cage with concentric hoops, to which the petticoat was attached. It was not easy climbing into a fiacre in one. The 'demi-monde' was a new name for ladies of easy virtue and also the title of a comedy by Alexandre Dumas Fils first performed on 20 March 1855.

D 3555 **La femme à barbe** 84
Charivari 16.2.1867

The light Muse and Tragedy meet at the cabaret. On the left is Thérésa,
who sang the most popular song in Paris, 'The Bearded Woman', and on
the right the tragic actress Mademoiselle Cornelie, whose successful
recitations of Racine and Corneille were a novelty in the world of cabaret.

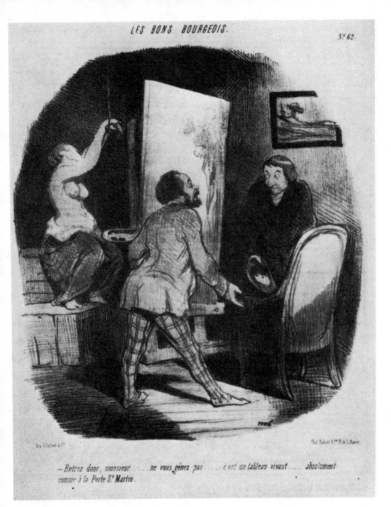

— Entrez donc, monsieur ne vous gênez pas c'est un tableau vivant absolument comme à la Porte S.^t Martin.

D 1538 Entrez donc, monsieur . . . ne vous gênez pas 85
Charivari 5.1.1847
THE MODEL
There was no need for the visitor to feel embarrassed. At the Porte St
Martin theatre he could see the same kind of thing . . . English actresses
wearing transparent leotards.

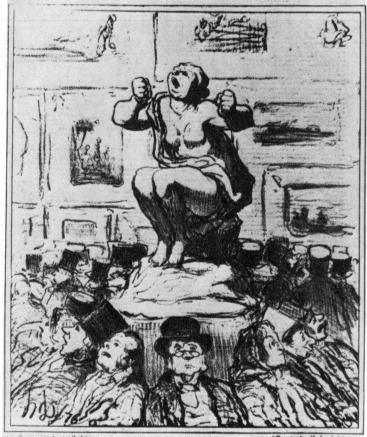

Triste contenance de la Sculpture placée au milieu de la Peinture

D 2963 Triste contenance de sculpture 86
Charivari 22.7.1857

Two years after the World Exhibition of 1855, the exhibition building
became available for the annual 'Salon'. There was plenty of space, a large
restaurant, and comfortable seats for the visitors, who turned up in even
greater numbers. Sculpture is feeling bored amongst all the paintings.
Daumier himself, open-mouthed and wearing a top hat, is sitting in the
foreground on the left.

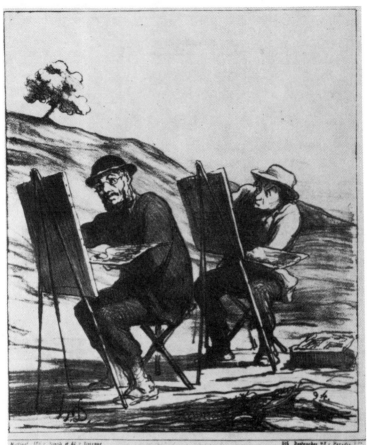

LES PAYSAGISTES
Le premier copie la nature, le second copie le premier.

D 3439 **Les paysagistes, le premier copie la nature** 87
Charivari 12.5.1865
The one copies Nature, the other copies the painting.

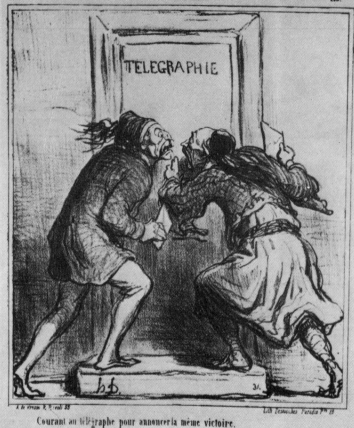

Courant au télégraphe pour annoncer la même victoire.

D 3554 Courant au télégraphe 88
Charivari 15.6.1867
FIGHTING IN CRETE
War reporting always remains the same. The Turk and the Greek are
both rushing to the telegraph office to report a victory.

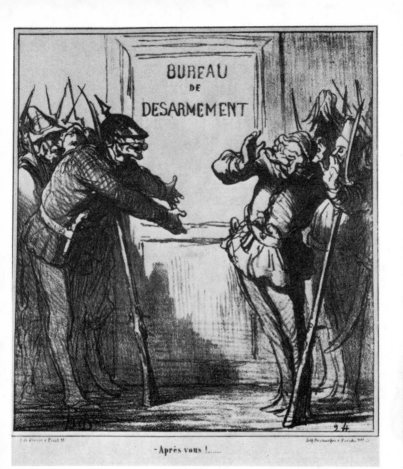

- Après vous !......

D 3640 **Après vous** 89
Charivari 14.5.1868
A contemporary Daumier would have drawn Russia and the United
States in front of the Disarmament Office, instead of Germany and
France!

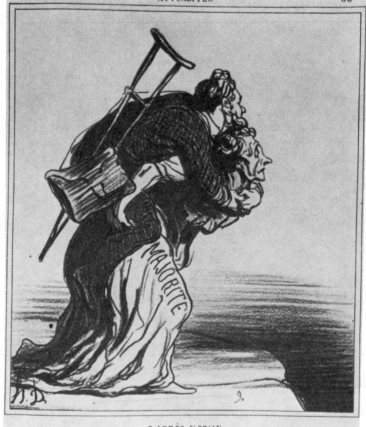

D'APRÈS FLORIAN

Je marcherais pour vous et vous verrez pour moi

D 3774 d'Après Florian 90
Charivari 29.3.1870
WAR THREATENING IN 1870
The blind majority has carried the lame Government to the edge of the
abyss.

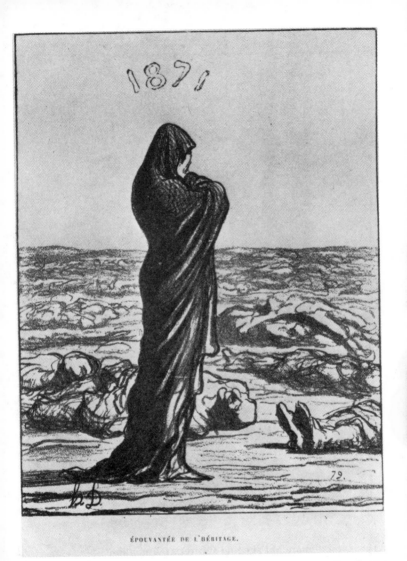

ÉPOUVANTÉE DE L'HÉRITAGE.

D 3838 **Epouvanté de l'héritage** 91
Charivari 11.1.1871
The outcome of the Franco-German War. With the simplest of means
Daumier expressed the sorrows of afflicted France.

Se demandant si ce ne serait pas le moment de lancer un autre faux pigeon.

D 3839 Se demandant si ce ne serait pas le moment 92
Charivari 13.1.1871

During the siege of Paris, contact with the outside world was maintained with the aid of carrier-pigeons which were taken out of the city by balloon. On one occasion the Germans intercepted two pigeons and returned them with highly coloured messages. However, this was discovered, and it gave the French a good laugh. Here, General Moltke is wondering what tale to tell the Parisians this time.

D 3845 **Ceci a tué cela** 93
Charivari 9.2.1871
France points out that the disasters of the war are due to the election
results, ie the great majority gained by Napoleon III shortly before the
outbreak of war.

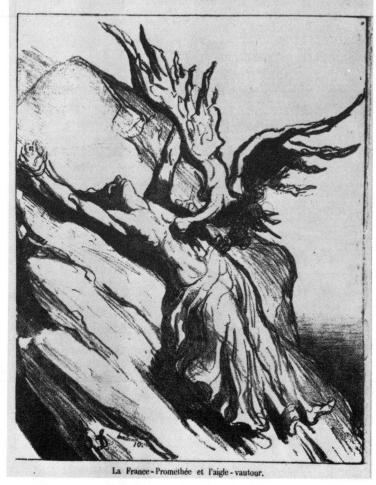

La France-Prométhée et l'aigle-vautour.

D 3847 **La France-Prométhée et l'aigle-vautour** 94
Charivari 13.2.1871
FRANCE
After the defeat by Germany, France was shackled to the rocks like
Prometheus. The text was taken from a poem by Victor Hugo written in
1853, and reprinted during the siege of Paris.

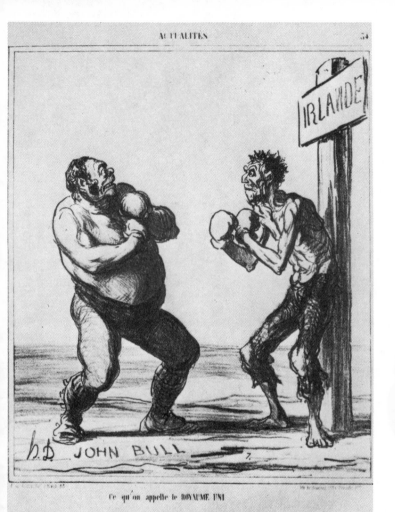

D 3491 **Ce qu'on appelle le royaume-uni** 95
Charivari 21.3.1866
The perpetual struggle in the 'United Kingdom' between starving
Ireland and well-fed England.

D 3955 Tête d'homme tournée vers la droite 96

Catalogue of Daumier's graphic work, 1878. Daumier was not at all keen on making etchings, but on one occasion he was unable to avoid doing so. This was at a musical soirée given by the Belgian pianist De Beriot (29.5.1872), when one of the guests had brought along an etching-plate. The head of a man is by Daumier. This etching was included in the first catalogue of Daumier's graphic work by the art historian Champfleury.